WHY AND HOW?

THE ROLE OF RESEARCH IN GRAPHIC DESIGN

SEMIOTICS, ANALYSIS, COMMUNICATION THEORY, SYSTEMATIC APPROACHES, SEMANTICS AND DISCOURSE THEORY

Why and How?

This book is intended to provide an introduction into the area of research methodologies for graphic designers. This important aspect of graphic design practice encompasses a wide range of practical and theoretical applications and this chapter introduces the field of research methodology as both an analytical and a practical tool for graphic designers. By investigating these twin areas of research in parallel, we aim to establish the role of critical thinking as a support to the development of what can be described as an engaged form of design practice.

Research is an intrinsic aspect of design practice and an essential part of the activity of problem solving. The designer is involved in a constant process of enquiry. It could be said that this process is predicated upon the notion of questioning – whether that leads to a discreet outcome or solution such as an industrial prototype based on a client's needs, or whether it contributes to the discourse and debate in the form of a proposition or a further question.

Primary theoretical models of design analysis and visual research will also be introduced, including semiotics, communication theory, systematic approaches to design problem solving, semantics, rhetoric and discourse theory as well as secondary research models and the testing of ideas and methodologies. The underlying emphasis throughout this book is on *why* we do what we do and *how*, through testing, feedback and rigorous approaches, we can be sure it is effective in the process of visual communication.

The discipline of graphic design can be defined in a variety of ways – the most persistent definition over

Methodology

The science of method, or a body of methods, employed in a particular activity such as the research aspects of a project. A logical, predefined and systematic strategy by which to undertake a graphic design project, to include methods of evaluation of experimental outcomes, a schedule for each stage of the project and a stated intention or purpose in relation to anticipated outcomes. It could also be employed to describe an approach to graphic design in general: a particular manner of working or a procedure used in the production of graphic design. Sometimes used in reference to organisation or a technique of organising and analysing, or a scheme of classification.

Method

A way of proceeding or doing something, especially in a systematic or regular manner.

Semiotics

The study of signs and symbols, especially the relationship between written or spoken signs and their referents in the physical world or the world of ideas. A core strategic method by which graphic marks, texts and images can be deconstructed and interpreted to determine their underlying meanings.

Semantics

The branch of linguistics that deals with the study of meaning. The study of the relationships between signs and symbols and the meaning that they represent.

Communication Theory

The body of work that relates to the study of communication and the ways in which meaning is transferred between individuals and groups through language or media.

its relatively short history has described the role of visual communication as a problem solving activity. This phrase, something of mantra for a large section of the design community, has been employed to describe the function of graphic design in a commercial sense – a sound bite that can be understood by the commissioners of designers – the clients.

This definition has not only legitimised the business and commercial aspects of design, but in parallel has led to a restricted description of the function of graphic design that often excludes what might be considered as the wider social, educational and informational roles of the profession. A broader interpretation of the term 'problem solving' could characterise it as a process of *analysis* and *synthesis*. Analysis relates to the methods of investigation, enquiry and understanding central to the research of a

project brief, concept or a particular context. Synthesis, meanwhile, is the means by which a designer is able to draw upon his or her initial analytical work and investigation to produce meaningful solutions or interventions. This ability is based upon the individual designer's intentions and their understanding of a complex range of interrelated issues affecting the creation of a successful graphic solution: audience, message or product, budget, materials, the means of production, the use of an appropriate visual language and the final form the outcome will take.

Many strategies can be applied to this basic framework for research in graphic design, and a number of these methodologies bring with them specific terms that are useful to the designer in describing what is taking place in the development and staging of a graphic design project.

Rhetoric
The study of the technique of the effective use of language. Written or spoken discourse used to persuade, influence or affect an audience.

Discourse
A body of verbal or written communication, especially between two or more participants. The act of discussion between parties, often in a formal manner.

Linguistics
The scientific study of language and its underlying structure.

LOOK!

A significant proportion of these terms are drawn from outside the field of graphic design and are borrowed from allied or tangential disciplines that have a long tradition of reflection and debate. Subjects such as linguistics, communication studies, philosophy and the social sciences, for example, have provided useful terms and definitions that designers have been able to adapt and employ in the foundation of a more descriptive language for the processes at work within the creation of visual solutions.

This is not to suggest that graphic design lacks its own specific language. Like many activities with a background and history in the technological arena, designers have developed a wide range of terms to describe what is at work in the production of visual communication. A large proportion of this terminology is rooted in the pragmatic description of technical issues such as colour and type specification and printing processes, or is influenced by the now commonplace computer and software language. Terms from outside the discipline have been utilised to describe a wider, less technically orientated approach to graphic design: theoretical terms such as 'gestalt' or 'rhetoric' often appear in the general discussion of graphic design or in relation to an individual designer's approach to a project.

The designer and historian Richard Hollis has described graphic design as constituting a language in its own right, *'a language with an uncertain grammar and a continuously expanding vocabulary'*. This expanding vocabulary partly refers to the relationship between graphic design and technology – a relationship that has served to define the subject during its historical development.

Epistemology
The theory of the underlying methods or grounds of knowledge, and the critical study of the validity, methods and scope of an established body of knowledge.

In relation to graphic design, this indicates the body of widely accepted knowledge that defines the discipline, including those theories surrounding legibility, written language and typography, as well as those drawn from outside of the profession.

Theories such as gestalt, for example, have been drawn from the disicpline of psychology and employed by designers in their working methods and practices. These ideas have influenced the everyday discussion of graphic design practice and the language used by designers to explain their working methods.

Gestalt
The organisation of a whole that is more than the sum of its parts. The implication of meaning communicated through the use of a part of an image or object, rather than the whole.

The most recent, and probably the most significant, development for contemporary graphic designers has been the arrival of the Apple Macintosh computer (first introduced in 1984), bringing with it a new language related to design. At the same time, this advance has made obsolete many of the traditional processes and terms used by graphic designers which related to an earlier age of mechanical, rather than electronic, reproduction. The debate surrounding the impact and value of this particular technology continues today, some 20 years after its initial introduction. The Macintosh has indisputably altered the landscape of graphic design, in particular allowing designers to function in a manner not previously possible and offering new creative opportunities with greater levels of control over production processes than were available in the past.

As a work-platform the computer has been influential in opening up new opportunities for designers, while also acting as a catalyst for much of the new debate within the profession, which could be termed a design discourse. The many discussions, for instance those surrounding notions of authorship, audience and legibility, exemplified in journals such as *Eye Magazine* and *Emigré*, have encouraged designers to explore new roles in what Dutch designer and educator Jan van Toorn has described as '...*the designer's field of operation'*.

Process and Product

The expanding definition of what might be considered the practice of graphic design has been influenced by factors other than technology. The speculative and more experimental work at the margins of contemporary graphic design, an area which could

Avant-garde

From the French term meaning literally the vanguard or front-runner. In the context of art and design, the term avant-garde is usually employed to describe the pioneers or innovators of a particular period or movement, often in opposition to the mainstream or status quo. Both avant-garde and vanguard were created by combining the old French words 'avant', meaning 'fore', and 'garde', meaning 'guard' and relate to its original usage by the military.

The notion of the vanguard could also be considered to be a heterodoxy – meaning different, contrary to or unorthodox (in fact, the term heterodox, rather than unorthodox, is the antonym of orthodox).

In graphic design the term avant-garde is rarely used in the discussion of contemporary design activity – more often than not the phrase is applied when discussing the history of the subject. This is not to suggest that there is no current avant-garde in graphic design, simply that the phrase has passed out of common usage.

Why and How?

be termed the 'avant-garde', together with a range of self-authored graphic projects have also exerted a strong influence. In many instances these offer new visual grammars and graphic forms and often focus on areas of graphic design previously constrained and under-examined by a singular, commercial definition of the discipline. This recent concentration upon the processes and methods involved in graphic design, the *how* and the *why* has allowed the area of research methodologies to take on a greater degree of significance to the subject.

The discussion of graphic design in university design departments, art colleges and design journals now routinely includes reference to a diverse set of issues that include the designer's responsibilities in a social, cultural and economic sense, the role of the designer in communicating to audiences and the construction of

meaning in verbal and visual languages. This wider field of operation has increased the exploration of the processes at work and has broadened the scope of research in graphic design.

For a long period during the development of the discipline the discussion of graphic design as an activity and its place in the wider community was left to external voices – those who received design rather than created it. Whilst in itself a useful tool for understanding graphic design, very few of these voices were heard from within the practice itself. Journalists, historians and cultural theorists who have written about graphic design have usually done so in terms of the artefact or end product and its effect. With very few exceptions the process of design problem solving, the methodologies employed by designers, their intentions and approaches to graphic design were left

Interestingly the relationship between the mainstream and the avant-garde operates in a very particular fashion. There are a number of celebrated designers around the world who are considered 'cutting edge' and radical in their approach to design whilst maintaining a successful commercial career with mainstream clients.

Designers such as Stefan Sagmeister and David Carson

have received critical acclaim for their ground-breaking and influential work, but have also attracted big corporate clients – in the case of Carson working later in his career with companies such as Microsoft.

This interdependency between the radical and propositional visual grammars of new and challenging work and the mainstream of design can be described as a process of *recoupment*. This phrase was

coined by the Situationists during the late 1960s to describe the ability of mainstream culture to accommodate 'outsider' ideas. The current situation is more symbiotic than the phrase *recoupment* suggests. The large fees paid by corporate clients support the time and space to allow designers to explore and experiment. In turn the new ideas and visual styles that emerge from this feed into the mainstream of the discipline

and become influential for a new generation of emerging designers.

under-explored in print and in the general discussion of the subject.

As the emphasis has moved away from the external commentator on design, it has instead become increasingly centred upon the growing community of designers and educators who are motivated by the idea of what has been termed the 'reflective practitioner'. Designers are now regular contributors to journals and speakers at lectures and conferences. We have witnessed an avalanche of graphic design publications, all with varying degrees of insight, which focus on the processes and intentions at work. Educational programmes and practitioners are beginning to build upon this graphic design discourse and are, in the process, expanding the definition of graphic design practice itself. This shift towards an engaged and reflective practice is not in direct conflict with the traditions of commercial facilitation. Instead the mutuality or interdependence between design experimentation and investigation and applied design thinking in a commercial sense is increased – allowing ideas of effectiveness and usefulness to inform original and propositional approaches equally.

As Ronald Barnett discusses in his book *Higher Education: A Critical Business*: '*the essential idea in this tradition in the Western university is that it is possible to critique action so as to produce more enlightened or more effective forms of action. The critical thinking in this tradition is a practice in the world, a praxis. Knowledge situated in practice is not, as is sometimes implied, a newish form of knowing alongside propositional knowledge, but is a tradition of enduring character.*'

Primary Research
The raw materials which a designer directly works with in relation to research. Primary research approaches might include marketing strategies such as audience surveys or interviews, or the direct testing of potential visual solutions within a 'real world' context.

Secondary Research
Established or existing research already undertaken in the field and used to support the designer's own research. This might include published surveys and/or interviews with potential audience groups, together with the analysis of a range of successful visual communication strategies within a similar context.

Tertiary Research
Research based on secondary sources and the research of others synthesised to simply restate what others have undertaken. A summary of the existing body of knowledge and accepted methodologies relating to the range of intentions, audience and context of the project.

Case Study 01: A Transferable Research Method

The South American design educator and writer Jorge Frascara has written that '...*the design of the design method and the design of the research method are tasks of a higher order than the design of the communications.*' This statement identifies a key shift in design thinking in recent years.

The drive towards a more social agenda for graphic design reached its height during the late 1990s with the reissuing of the *First Things First* manifesto. This call for a refocusing of the designer's role indicated a need for more considered discussion of the function and purpose of graphic design. Part of this discussion has been to explore how design might operate more effectively with a more methodological approach, achieved through the exploration of key aspects of the process of design thinking and making.

This project, by professional graphic designer Matt Cooke, proposes that one possible answer to this question is to develop a design methodology specifically to help tackle such social problems. While there are many designers who feel that such a pragmatic approach would stifle creativity, Cooke set out to prove that creativity needn't be compromised and that the design process can actually be enhanced when working within a structured methodology.

While working as a designer for a major UK-based cancer awareness charity, Cooke observed the way in which a detailed analysis and review structure was maintained consistently in the construction and evaluation of the campaign literature content, but noted that this thorough approach was not necessarily followed through and applied to the design process or practical implementation. The charity produced large

Matt Cooke's project (featured opposite and over the following pages) explores an unusual approach to the role of the designer in responding to a brief from a client. Rather than creating a series of visual proposals and variations of design solutions, he decided to concentrate on developing a working methodology for his client – a UK-based cancer awareness charity.

The resultant handbook presents a rationale for a method of visual thinking which is based upon a schematic diagram of the design process, together with a step-by-step, transferable system for the construction and testing of a range of public information products.

The handbook, which includes information on how to conduct market research and test the viability of alternative visual

strategies, was given to the client in order to rationalise the system of new design commissions and to save on the duplication of work in the areas of research and development.

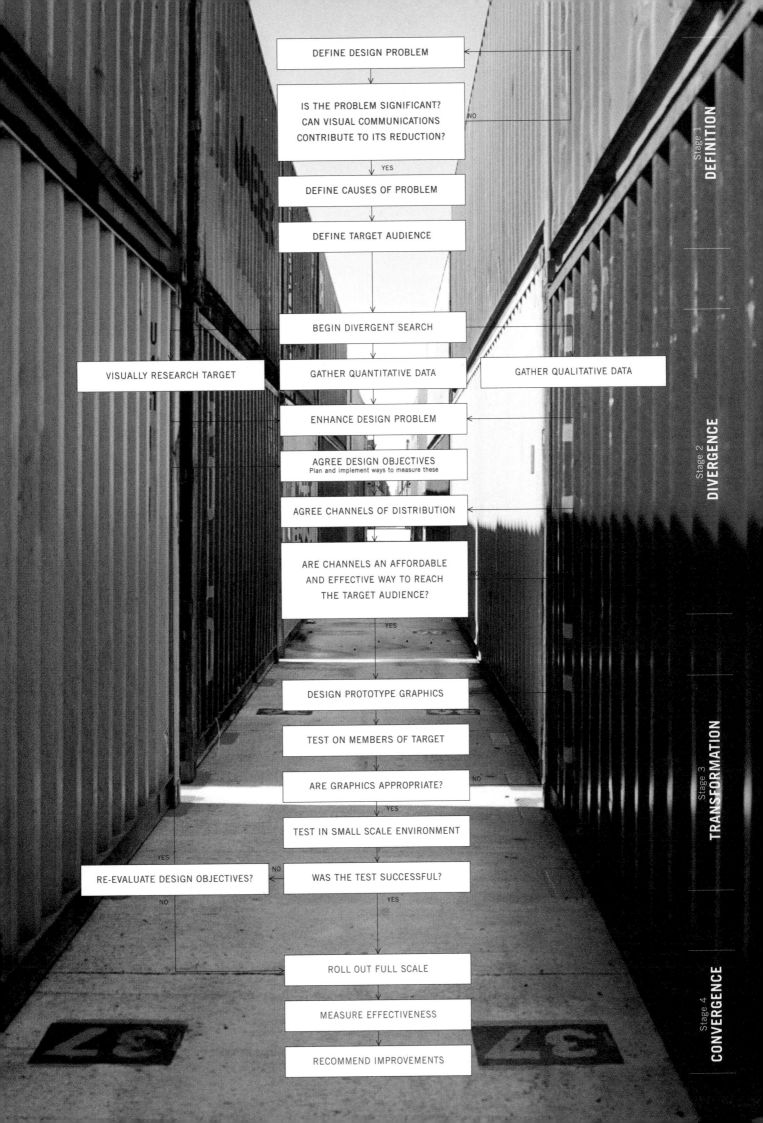

DEFINE DESIGN PROBLEM

IS THE PROBLEM SIGNIFICANT?
CAN VISUAL COMMUNICATIONS
CONTRIBUTE TO ITS REDUCTION?

NO

YES

DEFINE CAUSES OF PROBLEM

DEFINE TARGET AUDIENCE

BEGIN DIVERGENT SEARCH

VISUALLY RESEARCH TARGET

GATHER QUANTITATIVE DATA

GATHER QUALITATIVE DATA

ENHANCE DESIGN PROBLEM

AGREE DESIGN OBJECTIVES
Plan and implement ways to measure these

AGREE CHANNELS OF DISTRIBUTION

ARE CHANNELS AN AFFORDABLE
AND EFFECTIVE WAY TO REACH
THE TARGET AUDIENCE?

NO

YES

DESIGN PROTOTYPE GRAPHICS

TEST ON MEMBERS OF TARGET

ARE GRAPHICS APPROPRIATE?

NO

YES

TEST IN SMALL SCALE ENVIRONMENT

YES

RE-EVALUATE DESIGN OBJECTIVES?

NO

WAS THE TEST SUCCESSFUL?

NO

YES

ROLL OUT FULL SCALE

MEASURE EFFECTIVENESS

RECOMMEND IMPROVEMENTS

Stage 1
DEFINITION

Stage 2
DIVERGENCE

Stage 3
TRANSFORMATION

Stage 4
CONVERGENCE

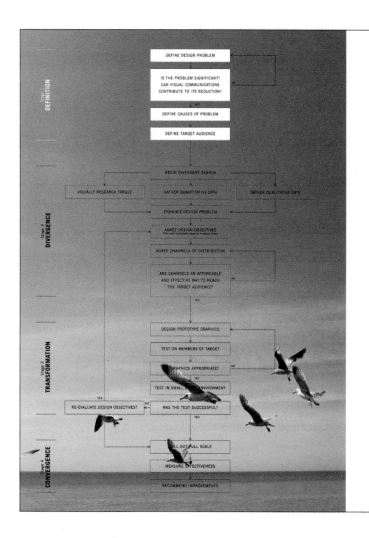

Stage 1
Definition

The first stage of the design process is called Definition. This is where the project is outlined in its initial form. At this stage the design team asks a series of questions to establish the nature of the problem and assess whether visual communications can make a significant contribution to its reduction.

The design team for this project included myself, Spencer Peppiatt (Design Assistant, WCRF), Maebh Jennings (Education Programmes Manager, WCRF) and Lisa Cooney (Education Assistant, WCRF). I should stress that I undertook all of the design work and only used the design team in this instance to approve ideas and develop concepts. The last two members of the design team (Maebh and Lisa) were also included because of their gender and age. WCRF clearly indicated at the start of the project that it was interested in communicating specifically with women between the ages of 16-34 (see page 28), and both of these women fall within this age bracket. Including members of the target audience in the design team gave us a greater chance of producing visual solutions that are effective in their intended environments. As Victor Papanek writes, "Most importantly, the

people for whom the design team works must be represented on the design team itself. Without the help of end-users, no socially acceptable design can be done." (Papanek 1985: 304).

Define the Design Problem
The first objective of the design methodology is to identify and define the design problem at hand. This can be any issue that an organisation is attempting to tackle, from raising awareness of its mission to attempting to change behaviour in members of the public. Clearly defining the design problem at the outset gives the design team a starting point from which it can begin to tackle the rest of the project.

Members of the WCRF executive committee became aware that the obesity epidemic we are experiencing is strongly linked to an increased risk of cancer. Since this is a relatively new finding, WCRF wanted to raise awareness among the UK public that this association exists, and to create a climate in which maintaining a healthy body weight is considered essential. Therefore, the design problem was: to raise awareness that there is a link between overweight/obesity and cancer.

volume print runs of detailed public information material for distribution through local doctors' surgeries, but very little attention was given to developing appropriate visual languages addressed to specific target audiences.

Taking the launch of a 'live' information campaign that was aimed at raising awareness of the links between obesity and cancer in young women as his case study, Cooke developed a working methodology which proposed, documented and followed a series of steps towards an effective and practical solution. By adopting a range of working methods from marketing and advertising, for instance, Cooke was able to create a successful solution to the brief. The testing of a range of proposed visuals, gathering of audience feedback, and the use of focus groups, feedback and surveys as well as more traditional graphic design

methods, led to the development of a highly sensitive and appropriate working methodology, which could be applied to alternative problems within the same field.

Cooke's working methodology is outlined within a self-produced handbook, which is divided into four sections defining each stage of the process. The first section is entitled *Definition,* and covers a range of activities which can help the designer to define the problem to be solved. Through the analysis of the problem and the identification of a target audience, the designer can refine the brief and develop a clear set of objectives for the project.

The second stage of the process, *Divergence,* covers a broad range of primary and secondary research methods, leading to a solid description of the context within which the work will function, alongside an audit

Stage one of the process involves definition of the project, including aims and objectives, prospective audience and potential visual outcomes. The step-by-step process outlined by Cooke at the beginning of the project (page 31) is broken down within each chapter, and highlighted sections of the diagram indicate to the reader the stage reached in the overall process of the work. The use of strong background images by

photographer Jim Naughten helps to give both a sense of visual drama and an overall cohesion to the series of project diagrams and illustrations.

Stage 2
Divergence

The divergent search is where the majority of background research takes place. It is where the design team broadens the parameters of the design problem, giving itself the best chance of finding a suitable solution. At this stage the team should put aside any initial assumptions about the way the final project might look, and assess for the first time the project as a whole. This is a process of dismantling initial preconceptions. Jones refers to the divergent search as "...the act of extending the boundary of a design situation so as to have a large enough, and fruitful enough, search space in which to seek a solution." (Jones 1991: 64). The divergent search also provides an opportunity for the design team to reassess the original definitions of the project made in stage 1; to test their validity; and also to find out which of these established parameters are changeable and which are fixed. Jones continues: "In short it can be said that the aim of divergent search is to de-structure, or to destroy, the original brief while identifying those features of the design situation that will permit a valuable and feasible degree of change. To search divergently is also to provide, as cheaply and quickly as possible, sufficient new experience to counteract any false assumptions that the design team members, and the sponsors, held at the start." (Jones 1991: 66).

The divergent search is also an attempt to get to know the target audience; to understand their likes and dislikes; to find out what motivates and stimulates them. In other words, its aim is to learn some of their values and attempt to learn their language – both verbal and visual. As Frascara notes: "In ethical communications, the producer has to speak a language that the audience can understand. If producers really want to communicate, that is, to be understood and not just listened to, they should remember that people can only understand things that relate to things that they already understand, and that it is impossible to communicate, therefore, without using the language of the audience in both style and content." (Frascara 1997: 17).

As part of the divergent search, the design team should pursue three main avenues of research: gathering quantitative data; gathering qualitative data; and visually researching the target audience.

28 / 29

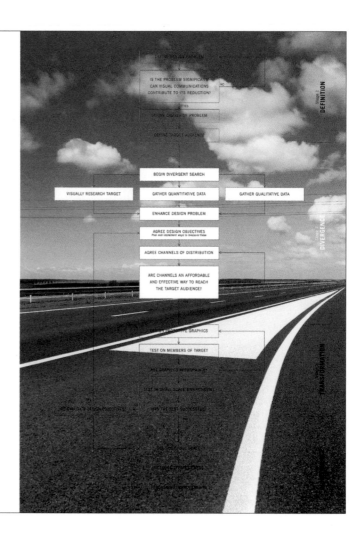

Stage two of the process, *Divergence*, outlines a range of contextual researches into the areas within which the intended project will operate, including an analysis of visual material competing within the same space. Again, highlighted sections of the diagram indicate to the reader the stage reached in the overall process of the project.

Further diagrams attempt to show the interrelationship between each stage in the process (opposite), demonstrating the ways in which each stage is interdependent, rather than a distinct and separate area of the investigation.

INITIAL
FERTILISATION

EVALUATION +
REGENERATION

DEVELOPMENTAL
GROWTH

PRODUCTION

THE DESIGN
PROCESS

Stage 3
Transformation

Having conducted the divergent search, the design team has in its hands the raw material which, when filtered through its collective imagination, and honed by its design experience, evolves into a set of proposed visual solutions. At this point the design team draws on its understanding of the results of the divergent search and applies them to its knowledge of design. This is the process of Transformation and, as Jones states, "This is the stage of pattern-making, fun, high-level creativity, flashes of insight, changes of set, inspired guess work; everything that makes designing a delight." (Jones 1980: 66).

Nevertheless, this is not an innocent practice. The design team is trying to effect a change in human understanding. And the knowledge gained in the preceding stages gives them a greater chance of achieving this. It is essential that lessons have been learned by the design team and that they do not simply revert to personal styles, or comfort themselves by aping current trends. Frascara warns: "Frequently, designs fail because of the exploration and use of visual languages foreign to the audience. Others, imitating fashionable styles, tint messages with ideologies that could be at odds

with those pertaining to the intentions of their content." (Frascara 1997: 13).

So it is crucial, at the Transformation stage, for the design team to examine its motives behind any proposed visual solutions. Choices made because they appear 'cool' rather than appropriate, or 'trendy' rather than suitable, need to be rooted out in favour of ideas that might better serve the content and context of the communication. To some this may sound unnecessarily didactic, but to the user-centred practitioner, it is common sense. Frascara continues: "The excessive importance given to aesthetics has centred the attention of designers, design educators and design historians on the formal aspects of design, that is, on the relationships of the visual elements with one another. Graphic design is, however, first and foremost human communication, and what the graphic designer does is construct a pattern, something similar to a musical score, to organise an event that becomes enacted when a viewer confronts the designed product." (Frascara 1997: 14).

42 / 43

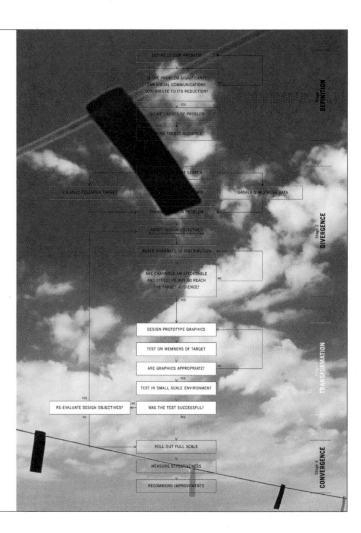

of the range of related material which already occupies the same visual space. This part of the methodology also includes an analysis of appropriate visual languages relevant to the target audience.

The third section, *Transformation,* describes the development and testing of a range of potential visual solutions. These experiments are tested by focus groups in order to generate feedback on a range of criteria: the use of colour, choice of typeface and/or image, clarity and legibility of information. By testing each of these elements separately, the designer hopes to gather more detailed and specific feedback in order to develop the structure of the campaign.

The fourth section, *Convergence,* details the production of the final design at full size, its implementation in the public arena and the

measurement of its effectiveness within this target environment. By incorporating specific design feedback within the data mapping and analysis of the campaign review structure, Cooke hopes to create a self-perpetuating system for gathering information and creating more effective solutions. This effectiveness can be measured both in terms of the quality and quantity of information delivered, against budgetary, production and distribution considerations, and also in the responsiveness of the target audience.

Stage three of the process, *Transformation,* centres on the range of visual experiments and focus group research conducted in the project.

At this stage of the project, Cooke attempts to build on the knowledge gained by conducting a thorough analysis of the context for the final work (stage two), allied to a strong understanding of the intentions outlined in the brief (stage one), in order to

propose well-grounded, functional visual solutions.

As with each of the earlier stages, highlighted sections of the diagram indicate to the reader their position in the journey through the project (opposite).

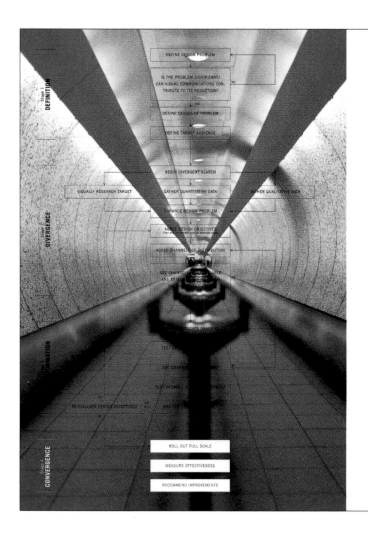

Stage 4
Convergence

This is the final stage in the design process. The background research has been conducted, design objectives have been agreed, channels of distribution assessed and prototype designs have been narrowed down. At this point the design team makes its final amendments and proceeds to roll out the product in the full scale environment.

Roll Out Full Scale
The ideal scenario allows the design team to do this with minimum effort, moving quickly from the prototype stage to completion. Jones emphasises the importance of moving swiftly to this point: "...to converge is to reduce a range of options to a single chosen design as quickly and cheaply as can be managed and without the need for unforeseen retreats." (Jones 1980: 67).

For the WCRF project, as discussed, it is not possible to roll out full scale until the tests have been completed in October 2003. However, this process was still observed as the design team moved from presenting final prototype graphics to the WCRF obesity committee, to printing 20,000 copies of the leaflet for distribution via the organisation's Newsletter. Once the committee's comments had been implemented it was very easy for the design team to complete the leaflet's design. The committee, having been sufficiently reassured throughout the design process, was also certain that its ideas would be implemented appropriately and did not feel the need to see another draft of the design.

This unexpected benefit of the methodology – that is, instilling greater confidence in those commissioning the project – enabled the design team to complete the project very quickly and with a minimum of additional proofing.

Stage four, the final stage of the process, is described as *Convergence* – the correlation of the results of all research and experimentation conducted throughout each of the previous stages in order to create an appropriate and functional final outcome.

Highlighted sections of the diagram (above) indicate to the reader their position in relation to the overall project, while further illustrations (opposite) give an indication of the designer's concerns with the creation of sustainable and useful design solutions.

Cooke chose to illustrate his research methodology with a series of illustrations reflecting the themes of useful design and social responsibility. Set on single pages throughout the handbook, the diagrammatic illustrations (above) convey a sense of purpose and take the polemical visual form of a manifesto for design.

A central part of Cooke's research had included the study of contemporary design manifestoes such as the reissued *First Things First* manifesto published in several design magazines in 1999. Building upon some of the aspirations described in that document, Cooke extended his rhetorical message through the use of strong visual statements reminiscent of warning signs.

An overview diagram of the research and development processes (opposite) also shows a reflection on the procedures outlined in the initial proposal diagram (page 31), presenting the flow of the project as a more circuitous journey, rather than the linear route planned at the outset.

DEFINITION

A DEFINE DESIGN PROBLEM
A1 IS THE PROBLEM SIGNIFICANT?
CAN VISUAL COMMUNICATIONS
CONTRIBUTE TO ITS REDUCTION?
B DEFINE CAUSES OF PROBLEM
C DEFINE TARGET AUDIENCE

DIVERGENCE

A BEGIN DIVERGENT SEARCH
A1 GATHER QUANTITATIVE DATA
A2 GATHER QUALITATIVE DATA
A3 VISUALLY RESEARCH TARGET
B ENHANCE DESIGN PROBLEM
C AGREE DESIGN OBJECTIVES
D AGREE CHANNELS OF DISTRIBUTION
E ARE CHANNELS AN EFFECTIVE WAY
TO REACH THE TARGET

TRANSFORMATION

A DESIGN PROTOTYPE GRAPHICS
B TEST ON MEMBERS OF TARGET
C ARE GRAPHICS APPROPRIATE?
D TEST IN SMALL SCALE ENVIRONMENT
E WAS THE TEST SUCCESSFUL?
E1 RE-EVALUATE DESIGN OBJECTIVES

CONVERGENCE

A ROLL OUT FULL SCALE
B MEASURE EFFECTIVENESS
C RECOMMEND IMPROVEMENTS

Key Concepts

A significant shift in the range of approaches to contemporary design has come about as a result of the debate surrounding the notion of graphic authorship and what this might constitute in the future for graphic designers. While definitions of authorship in graphic design continue to be expanded and updated by designers, design writers and educators, it is useful to consider a singular interpretation as a starting point for debate.

Traditionally, graphic designers are involved in a process of facilitation: put concisely, the business of design is to communicate other peoples' messages to specified audiences. This might be for the purposes of providing general information

(such as a train timetable or road sign) or to persuade a target audience about a particular product through its packaging and promotional design. While this may be a crude definition, it is clearly applicable to the broad majority of design practices in the commercial arena: graphic designers are commissioned to employ their skills as a communicators in the service of a client.

The notion of authorship lies in the possibilty that designers can also operate as mediators — that they can take responsibility for the content and context of a message as well as the more traditional means of communication. The focus for the designer might be on the transmission of their own ideas and messages, without the need for a client or commissioner, but still remaining fixed on the effectiveness of communicating with an audience. This can also operate in a commercial sense — a client might choose to employ a graphic designer because they have a particular visual style or method of working that would work in tandem with their message or product. This could be described a designer's signature style, and there are many celebrated or well-known designers who are commisioned purely because of a body of work that is concerned with particular themes or is popular with a particular audience.

the designer as author

the author as designer

METHODS:
WAYS OF THINKING

ANALYSIS AND PROPOSITION

RECORDING, EVALUATING AND DOCUMENTING A RANGE OF VISUAL AND VERBAL STRUCTURES, LANGUAGES AND IDENTITIES

METHODS: Ways of Thinking

Research methods can be defined as ways of approaching design problems or investigating contexts within which to work. This chapter focuses on the thematic approaches to problem solving and the construction of rational and logical systems of design thinking. Through knowledge of existing conventions and the development and application of a personal visual vocabulary, designers are able to make more effective use of their perceptions and discoveries, and to work practically and creatively with reference to a wider cultural context. Systematic research methods encourage designers to develop a personal and critical point of view through the recording, documenting and evaluating of visual and verbal structures, languages and identities in the wider environment, and then applying those findings within their own work.

The adoption of a rigorous methodology that either addresses the specific requirements of the brief or sets a series of boundaries within which to work on a broader visual investigation, can help the designer to focus a project and define the exact problem, or series of problems, to address. Breaking the project down into a set of intentions, each with defined parameters and a predetermined level of background knowledge or experience on the part of the designer, makes the task more achievable and the goals of each stage of the process more explicit.

Each of these areas will be explained in detail within this chapter, showing the developmental process of a strategic design methodology relevant to the context of the brief. Examples of work illustrating key concepts from both the professional and academic fields are included to guide you through each stage of the

Practical Problems

A practical problem originates in the real world and is related to pragmatic issues and conditions such as cost, production and technology. It may also be influenced by its context, for example, the need to explore legibility and typographic form in relation to public signage for the poorly sighted. This is an applied area of research and investigation, in that the solution itself may lie in constructing or posing a specific research problem. The outcomes of applied research are tangible and offer real world or commercial solutions to already existing needs.

Applied Research

Applied research is the the investigation of a practical problem.

Research Problems

A research problem is typically developed in response to a subject or theme that the designer does not know or fully understand. A research problem may arise from or be motivated by a practical problem to be resolved – *a field of study*. This then helps to define the *project focus* of the research and provides a specific question to be explored. The research, investigation and development – the body of knowledge and understanding gained through research – is then applied to a practical situation or problem. Sometimes this is referred to as pure research and its outcomes are frequently conceptual, for instance in the development of an appropriate visual vocabulary for a specific theoretical context.

THE RESEARCH PROCESS

PROBLEM/IDEA

Solves Generates

RESEARCH RESEARCH
OUTCOME QUESTION

Finds Defines

RESEARCH METHODOLOGY

Everything depends on design

In English the word **design** is both a noun and a verb. As a noun, it means — among other things — intention, plan, intent, aim, scheme, plot, motif, basic structure, all these being connected with cunning and deception. As a verb — **to design**, meanings include to concoct something, to simulate, to draft,

The word occurs in contexts associated with cunning and deceit.

to sketch, to fashion, to have

A designer is a cunning plotter laying his traps.

designs on something.

Vilem Flusser The Shape of Things: A Philosophy of Design

process, and to help define each specific area of investigation undertaken by the designer.

The first task for the designer is to identify what he or she is attempting to achieve with the project. Within commercial graphic design, this might be described in the brief as the intended message that is required to be communicated, or the target market which a commercial enterprise wishes to engage with. In this instance, the work undertaken is a form of *applied research*. Alternatively, in an academic context the aim might be broader; such as the proposal of a concept, or an idea for the student to visually investigate and respond to. In this case, the work undertaken is a form of *pure research*. In either case, the terminology may vary (see diagram pages 50-51), and the distinctions between different stages of the process may be more or less well defined, but the

breaking down of the proposal into separate areas of investigation and the definition of a project rationale is a useful preliminary exercise.

Any design brief can be broken down into three areas for specific interrogation: a *field of study*, a *project focus* and a *research methodology*.

The Field of Study *(where will the work be situated, and what function will it fulfil?)*
This area describes the broad context for the work. This could be, for instance, the field of wayfinding and signage within information design, or an audience-specific magazine page layout aimed at a particular cultural group. The first task facing the designer is to research their field of study, to acquire knowledge of what already exists in that area, and the visual languages which can be directly associated with the

Pure Research
The investigation of graphic and visual languages in a propositional sense, rather than the development of those which have a pre-determined commercial application.

Although this form of research may not lead to 'real world' practical solutions, this does not obviate the need for a thorough analysis of the context of the work in relation to potential audience and the

stated project intentions. The outcomes of pure research are propositional and offer potential visual solutions to as yet undefined needs.

FIELD OF STUDY	←→	FOCUS	←
CLAIM	←→	EVIDENCE	←
CRAFT	←→	TOOLS	←
INTENTION	←→	THEORY	←
QUESTION	←→	DISCOURSE	←
IDEA	←→	EXPERIMENT	←
PROBLEM	←→	INVESTIGATION	←

ANALYSIS

METHODOLOGY	←→	REFLECTION
TEST	←→	EXHIBITION
PROCESS	←→	PRODUCT
CONTEXT	←→	MESSAGE
AUDIENCE	←→	THESIS
PRODUCTION	←→	ARTEFACT
COMPARISON	←→	SOLUTION

SYNTHESIS

specific target audience or market for the design. The designer needs to consider both the external position of their intended work (the explicit aim of the communication itself) and its internal position (the relationship between this particular piece of visual communication and others within the same context).

This is very important, as contemporary cultures are saturated with displays of visual communication, in the form of advertising, information graphics, site-specific visual identities and images related to entertainment or decoration. If a piece of graphic communication is to be displayed within this arena, the designer needs to be aware of how it relates to competing messages, and how the problems of image saturation or information overload might be resolved in order to communicate effectively.

Of course, the designer will become more familiar with a specific field of study through professional experience. By building a relationship with a particular client and working on a number of projects aimed at a distinct audience or cultural group, the designer can learn which forms of communication are likely to be more (or less) effective. Field of study research then becomes more intuitive, based on prior experience and learning, and the designer is able to move more quickly toward a project focus and methodology.

Field of study research takes a variety of forms, dependent on the context of the work. Market research might be appropriate to some briefs, whereby the designer seeks out other work in the same field and analyses and compares the visual forms of communication relevant and readable to a specific audience. This could mean a review of comparative

Analytical
Adjective relating to *analysis (n.) – the division of a physical or abstract whole into its constituent parts in order to examine their interrelationships.* As a design methodology, this involves the designer becoming more familiar with the specific message, audience, appropriate visual language and the requirements of the client.

Propositional
Adjective relating to *proposition (n.) – a proposal for consideration, plan, method or suggestion.* This usually takes the form of a hypothesis or what might be termed a qualified assumption, supported by some form of material evidence. In the case of graphic design, this means the definition and testing of potential visual solutions.

Design involves both these aspects of research. Designers need to be aware of the context within which their work will be interpreted and read, and the possibilities offered by audience familiarity, materials and budget constraints. At the same time the solution also needs to be innovative – offering a new way of presenting the information.

Different graphic design projects may involve each of these areas of research to a greater or lesser extent, depending on the brief, the specific qualities of the message to be communicated, and the relationship between client, designer and audience.

Design is never neutral

The act of designing can never be an entirely neutral process, since the designer always brings something extra to the project.*

*Robin Kinross The Rhetoric of Neutrality – Design Discourse: History, Theory, Criticism

A design cannot fail to be informed, in some measure, by personal taste, cultural understanding, social and political beliefs, and deeply held aesthetic preferences.∞

∞Rick Poynor No More Rules – Graphic Design and Postmodernism

products or visual systems, working with a client to establish their position in the marketplace or their aspirations to communicate with a particular audience. In most cases sophisticated visual languages already exist which attempt to engage those audiences, and the designer should become familiar with their vocabulary, even if his or her intention is to create a new form of communication which sets itself in opposition to that which already exists.

Cost implications are also important to consider at this stage of the project. The costs of materials, print reproduction or other media (web design, digital storage etc), labour and overheads need to be taken into account against the intended budget for the project. The designer and client need to have a strong idea of the range of materials available and affordable to them, and the implications upon the design itself. If the budget can only cover the cost of two-colour printing, for instance, then those restrictions need to be put in place in advance and then turned to the designer's advantage in seeking innovative responses to the range of techniques and materials available.

The Project Focus *(what will the specific context and function of the work be within the wider field of study already defined?)*
Once the designer has researched the field of study and become familiar with the broader intentions of the brief, a specific project focus is necessary in order to demarcate the exact intentions of the work to be undertaken. At this stage, the designer should be able to describe the message which is to be communicated to a specific audience, or within a specific context, and the aims and objectives of that communication – for instance, to persuade the receivers of the message to

I keep six honest serving-men
(They taught me all I knew);
Their names are What and Why
and When
And How and Where and Who.
Rudyard Kipling

act in a particular way (e.g. buy this product, go to this event, turn left at the next junction), or to clearly communicate a particular emotion or identify with a subcultural group.

The focus may change during the lifespan of a project, becoming broader and then being redefined in an ongoing process of critical reflection and reappraisal. There are a number of ways in which the narrowing down and refining of a project focus might take place. Two useful models for the designer to use in order to ascertain the context of their work and define a particular focus are set out diagrammatically in the following pages.

The first research model, which we will term the <Context-Definition> model, gives a greater emphasis to the investigation of a field of study. In this model the designer attempts to become more expert within the field of the brief and the project focus is defined in response to an identifiable need within that area. The second model, termed <Context-Experiment>, still requires the designer to undertake a broad preliminary analysis of the field of study, but the practical work on the brief itself begins earlier in the process than in the <Context-Definition> model. Usually this is done through a series of tests or experiments which can be evaluated within the field of study, leading to a redefinition of the project focus dependent on the results gathered.

It is important here not to lose sight of the original project intentions, and to work through the experiments in a systematic way. The <Context-Experiment> model will inevitably lead to a number of 'failed' experimental outcomes, as each small 'test' is

<Context-Definition>
Initial work in this model usually involves a thorough analysis of a broad range of secondary research, mapping the territory to be investigated and determining the range of work which has already been done within the target context.

Once a solid understanding of the context has been reached, the focus for the project can be determined, and a working methodology defined. Primary research is usually beneficial at this stage, in the form of direct surveys of target audiences and visual experimentation to test appropriate visual languages.

The results of these preliminary visual and contextual experiments can then help to define the specific project intention, together with an appropriate methodology which allows the testing of a range of potential outcomes.

Context Definition

FIELD OF STUDY

FOCUS

an attempt to gain feedback in the definition of the project focus. In fact, if an experimental piece of visual communication is unsuccessful when tested with a target audience or in a specific context, then this should still be seen as a positive exercise in gathering information on the project focus. By determining what does not work, as well as what potentially does, the designer is in a far better position to arrive at a more successful resolution.

The Research Methodology (how will the designer go about researching and developing the project in response to the context and intention outlined above?) A research methodology is simply a set of self-imposed rules by which the designer will engage with a project. Once the intention of the work has been clearly stated, together with a detailed mapping of the field of study and the definition of a focus for the visual message to

be created, the designer needs to outline exactly how he or she intends to go about developing the project and testing ideas in order to create an effective solution to the brief. The intention here is to develop systematic ways of working which lead progressively to a more successful outcome, based on experiments and visual testing, materials investigation and audience feedback, and the goal is to produce a piece of graphic design which is effective, useful or engaging.

The adoption of a strong research methodology should help the designer to make work which can be justified in terms of the processes used, and can be predicted to get closer to this goal. It is also important to plan the work in advance, including a rough schedule identifying when the designer expects to undertake each experiment, and the proposed deadline for finishing the project. Whether within the areas of

Historical Research

Seeks to reveal meaning in the events of the past. Historical researchers interpret the significance of time and place in ways that inform contemporary decision making or put current practices into perspective.

Descriptive Research

Observes and describes phenomena.

Analytical Research

Generates quantative data that requires statistical assistance to extract meaning. Analytical research requires testing and estimation and is particularly concerned with relationships and correlations in an attempt to predict outcomes.

Experimental Research

Attempts to account for the influence of a factor in a given situation. Experimental research defines relationships

of cause and effect by changing the factor to be studied in a controlled situation.

Meridith Davies 'What's so Important about Research?' Statements, American Center for Design (ACD), Vol.6, No.1, (Fall 1990)

commercial graphic design or design study, deadlines are usually given as a part of the brief. Even where this isn't the case, for instance when a designer is conducting a personal visual investigation, it is still important to plan a time frame for the project.

'Experimentation' is something of a buzzword in contemporary graphic design. An experiment is a test or investigation, planned to provide evidence for or against a hypothesis – an assumption which is put forward in order to be verified or modified. When a designer is working towards producing a piece of work, a series of visual tests or design experiments might be useful in gathering feedback on new ideas and forms of communication. However, experimentation is not a virtue in itself – it has to operate within a set of precise guidelines, delineating the intention and context of the experiment, together with the ways in which feedback

will be gathered and results will be measured. In short, a design hypothesis might be that the creation of a particular visual form will communicate a particular message to a given audience. An experiment to test this hypothesis would then involve creating variations of that form and gathering feedback from target audiences or experts within that particular field of design in order to measure the relative success or failure of the work to communicate as intended.

Another key question to consider at this point is, how do we measure? In setting up a series of 'experiments', which might involve trial runs with alternative visual strategies in response to a defined problem, how is the designer to go about gathering feedback in order to evaluate which of the visual applications is the more successful? There are a number of ways to respond to these questions. Market research, especially in relation

<Context-Experiment>
Initial work in this model usually involves looser mapping of the territory to be investigated, an analysis of the range of work which has already been done within the same context, and a specified intention for the work within this context.

The focus for the project needs to be determined earlier than in the <Context-Definition> model, particularly through the

definition of what the designer, and the client where appropriate, wishes to achieve.

Distinct visual experiments to test appropriate visual languages and strategies are then conducted in order to determine a range of potential solutions. It is important that an overarching strategy is employed by which to critically evaluate and reflect upon the relationship between each individual experiment.

FIELD OF STUDY

FOCUS

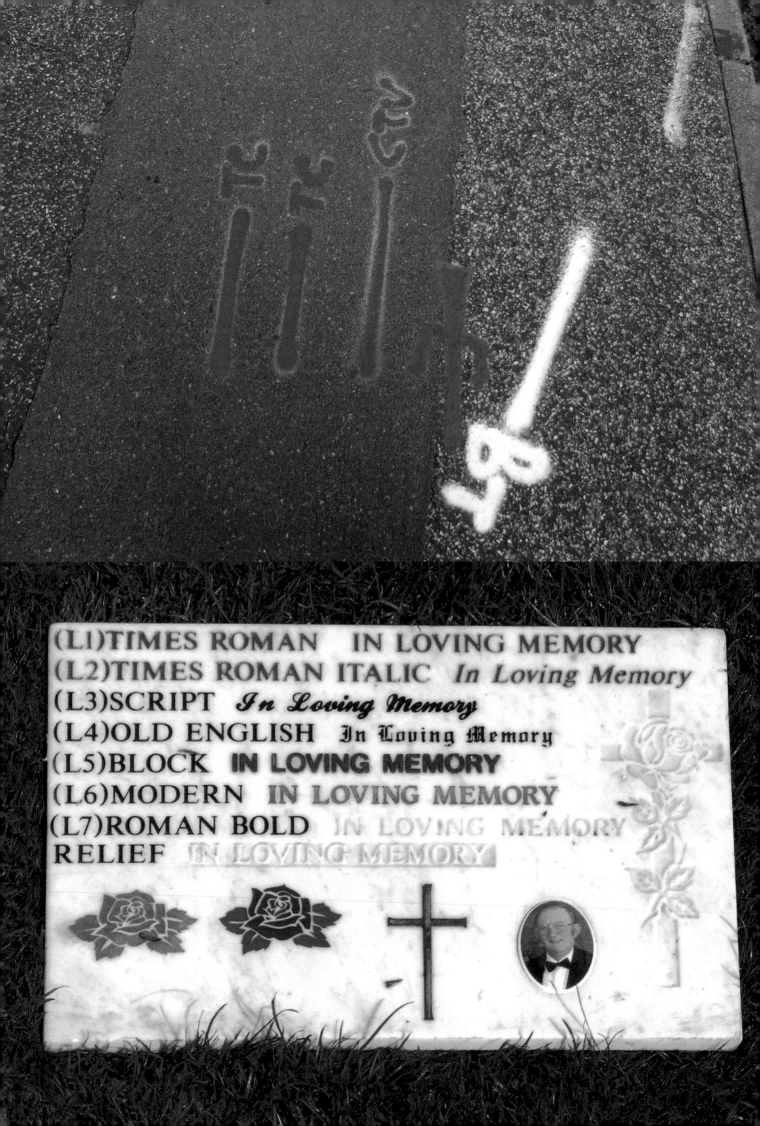

(L1)TIMES ROMAN IN LOVING MEMORY
(L2)TIMES ROMAN ITALIC *In Loving Memory*
(L3)SCRIPT *In Loving Memory*
(L4)OLD ENGLISH In Loving Memory
(L5)BLOCK **IN LOVING MEMORY**
(L6)MODERN IN LOVING MEMORY
(L7)ROMAN BOLD IN LOVING MEMORY
RELIEF IN LOVING MEMORY

to product advertising and marketing, has developed some successful methods of testing materials and form through the use of focus groups, statistical analysis of surveys and audience observation techniques. Some of these techniques can be linked to anthropology and the study of human interaction within social groups, whilst others derive from more scientific methods of data gathering and quantitative analysis. It is also important to understand the differences between what are termed quantitative and qualitative methods. The designer will often use both forms of analysis, and their application may prove more or less useful depending on the specific brief and target audience, but the methods themselves are distinctly different.

Quantitative analysis is based upon mathematical principles, in particular statistical methods of surveying and interrogating data. By producing a number of

visual forms to test, the designer can place these objects in specific locations in order to 'count' positive and negative responses from a target audience. This could mean conducting a survey within the target audience group, using multiple choice questions devised to score against a set of criteria. The data gathered can then be converted into numbers, to be analysed statistically to find the most successful visual form. Of course, as the size of survey group or sample increases, we anticipate that the results will become more accurate.

However, if the survey questions are not strictly controlled or specific enough, there can also be a tendency for results to become blurred. Human responses to questions are not the same as results gathered within scientific experiments – reactions to a visual message ('I quite like it', as against 'I like it

Type as a Signifier
The use of a particular type style: the typeface, its size, weight and colour, as well as its position within a particular context, can be a deliberate choice made by the designer in the construction of a message.

Type carries a resonance with its intended audience – not only does it carry meaning through the content of the written words themselves, it also communicates through

composition and the semiotic reading of type as image.

Other forms of lettering, such as the surveyor's marks shown opposite, constitute a specific language, carrying detailed meaning to a specific group of readers (in this case, the location of pipes and cables buried under the ground).

a lot') cannot be weighed in the same way as, for instance, the mass of a residue formed by the reaction of two chemical elements. People often have a tendency to score their reactions within the middle range of the options available to them, which can result in a statistical steering of data away from any radical or innovative propositions. This can lead to an overemphasis on that data which is largely contained within a conservative, middle ground set of replies, erroneously indicating a resistance to change.

Quantitative methods do apply quite strongly, however, in the areas of materials investigation and technology (which is explored more fully in Chapter 5: Process and Materials). If a piece of work is to be produced in multiple numbers (as almost all graphic design is), then the criteria for choice of materials – its resistance to age deterioration or discolouration, distortion,

stability and its fitness for purpose – can be subject to quantitative evaluation. Materials testing, through the use of alternative substrates and surfaces on which to print, or technologies with which to construct and view online data, is an important area of design experimentation, and experiments within this area can usually be measured with reasonably accuracy.

Similarly, the cost implications involved in the selection of materials and production methods can be compared and measured against the constraints of the project budget. When a piece of work is to be manufactured as a long production run, especially in printed form, the costs involved in even the smallest design decision are magnified accordingly – from the cost of ink and paper stock to the labour involved in folding, collating, cutting and finishing.

Authorship
The involvement of the designer in the mediation of the message to an audience. It can be argued that through the creation of visual messages, the designer has an equal role to play in the ways in which a piece of visual communication is read as the originator of the message itself.

The designer, as a form-giver or channel through which the message is passed, can play a key role in actually shaping the content of the message. Some design theorists have borrowed the notion of the *auteur* from film theory in an attempt to build on this notion, while others have been provoked into a heated response which foregrounds the neutral role of the graphic designer within a commercial arena.

The Dearth of the Author

The idea that a designer was an artiste first and a communicator second (or third) was quaint at the outset but has offered diminished returns over the long term. Although individual personality routinely plays a key role in visual communication, it must be the result, not the goal, of solving design problems.

Steven Heller The Me Too Generation – The Graphic Design Reader

Printers set up their machines to operate using the most common formats and production runs. This usually implies a reliance on standard ISO (International Organisation for Standardisation) or imperial paper sizes and colour palettes (CMYK four-colour process or Pantone spot colours for instance). If the designer chooses to work outside of these standards, set-up times for production will be longer and the costs will, therefore, increase. Any tasks which require hand rather than machine finishing will also incur an additional cost. As such, the economic aspects of the project need to be planned carefully in advance, and quantitative methods can be useful for the designer in calculating the budget for the project.

Qualitative analysis in design, on the other hand, is based on subjective responses to visual forms and the reading of graphic material by a viewer. Often this is done by the designer him or herself, in the form of critical self-reflection. It is also implicit, of course, in the surveys and focus groups mentioned earlier in this section (see quantitative analysis). The reading of images and visual signs is a qualitative act in itself, although some responses can be evaluated statistically as a form of quantitative analysis, the initial data gathered is based on human reaction to the visual forms and experiments presented.

A key qualitative method for designers involves the semiotic analysis, or deconstruction, of design artefacts. What this means in practice is the reading of explicit and implicit messages within a visual form, to determine the range of meanings which might be communicated to an audience. If the principles of visual communication are broken down into the twin themes of the encoding and decoding of meaning

Critical Reflection

The process by which the designer reviews a project outcome or evaluates the success of an experiment, by testing its effectiveness against a predetermined set of criteria. These criteria may be either self-imposed or may be a part of the brief itself.

Within the commercial arena, market testing and measuring the effectiveness of a graphic message are often rigorously applied. Where the designer is working in a more speculative environment, the means by which effectiveness can be determined must be measured against the project's intentions. For instance, a project which sets out to make visible certain underlying characteristics of a text within a book would need to be evaluated in ways that reflect that specific objective. Readers could be asked to interpret the design in order to ascertain whether the implied meanings are made clear. The designer could also draw on contextual research which analyses the range of graphic languages operating within the same arena, thus describing the range of already accepted codes on which to build.

(synonymous with the acts of writing and reading), then the range of implied messages and interpretations can be largely determined in advance. Graphic design usually operates within very specific boundaries, where the intention of the brief is made clear by the client or designer in advance. Certain vocabularies drawn from communication and language theories can also help the designer to describe the range of activities involved in the process of visual communication.

These methods are useful for the graphic designer, as they can help to build constraints into the visual message in order to guide the viewer toward the desired reading, rather than a misinterpretation, of the message. By understanding how the message might be received by a range of different readers, the designer can try to avoid unintentional ambiguities. These themes will be explored in further detail in

Chapter 3: Visual Research and in Chapter 4: Audience and Message.

Denotation

The primary, literal meaning of a piece of communication, usually within a particular target audience or group of readers. This aspect of reading (decoding) and writing or making (encoding) meaning within a message is fundamental to all forms of communication. Graphic designers need to be aware of the uses of particular visual signs and symbols, and their common meanings, within a target group. Information design and the other areas of graphic design which attempt to reach a broad audience, rely heavily on the denotation of specific meanings within visual forms in order to make the intended message clear.

Connotation

The range of secondary meanings within a form of communication (such as a text; written, verbal or visual). The meaning of the image and how we 'read' it is not fixed by its creator or author but is equally determined by the reader. As such, there are often a range of personal interpretations of the meaning inherent within a message across the audience spectrum. Certain subcultural groups, for instance, may use visual signs which are adopted from the parent culture but are used to signify alternative meanings to their primary denotative signification.

THEORY

PRAXIS

PRACTICE

ClaimQualific

Claim and Evidence

Central to any design research activity is the relationship between the viability of the research question and the methodology employed in the exploration of the subject under examination.

It is useful to consider this notion as if one was constructing an argument. The rhetorical aspect of graphic design is a central defining feature of the discipline. To create a successful argument it is important to be explicit in two key factors; the *claim* that the designer is making and the *evidence* he or she provides to support their claim.

The assertion – *the claim* that the designer is making – should be both substantive and contestable. The contention proposed should be supported by relevant and valid evidence. This evidence should be introduced in stages, in some cases it should be treated as if it were a sub-claim and may itself need to be supported by further evidence.

The qualification of the design proposal – *the evidence* to support the claim – helps to fulfil a number of requirements in a successful design. It can help substantiate the choices made by the designer when presenting the work to the client, give greater credence to the visual vocabulary adopted, and lead to a more thoroughly tested and therefore, probably, more successful outcome.

Evidence

Primary Sources

The raw materials that the designer works directly with in the research. These sources are implicit in an interrogation of the broader field of enquiry, the analysis of reference material, the examination of alternative approaches and existing experimentation within the field and the relation of the proposed work to wider cultural contexts.

Secondary Sources

Established or existing data from studies already undertaken, which are used to support the designer's own research. The critical formulation of design concepts and messages, mediation of the message, consideration of audience, selection of appropriate media/formats, articulation of visual language, media testing and development in evolving a thorough project.

Tertiary Sources

Research based on secondary sources synthesised to simply restate a summary of research that others have undertaken.

Case Study 02: Mapping Meaning

An important aspect of design authorship and the self-initiated editing and visual communication of content lies within the field of information design: The designer can collect information and treat it in such a way as to emphasise new meaning which may be inherent in familiar content.

Mapping, the systematic organisation of complex information in a form which may be transported and reinterpreted, is an activity that has much in common with graphic design – the collecting, editing and re-presentation of information in a communicable visual form might be defined as the very core of the discipline. Designers have a responsibility to create work which is both accessible and understandable to its intended audience. As such, it is essential that research is conducted into the target audience for a particular

message in order to ascertain the quality and appropriateness of materials used and visual language adopted, together with the range of contexts within which the work might be viewed and interpreted.

Designer and educator Alison Barnes used the tools of the cartographer and the information designer within her project, which attempted to investigate the human dimension often lacking within traditional forms of urban mapping such as street maps. Whilst one might expect to find details of historically or culturally important locations, together with street names and navigational devices on any given town map, Barnes was interested in displaying alternative visual signs that demonstrated human intervention and the traces of its use as both a social and an architectural space. Her maps, detailing alternative views of the area of New Basford in Nottingham, chart

The images featured here were taken by Alison Barnes as part of the background research and investigation into the changing nature of the New Basford area of Nottingham. Electing to analyse the range of vernacular and 'low-tech' signs of the area such as graffiti, Barnes systematically documented the 'signs' of each street to produce a range of topographical maps of the area. The term vernacular in this context refers to the study of

non-designed typography such as graffiti as a valuable source of information about our culture and lives.

THE SIGNS ARE ALWAYS THERE, THEY JUST NEED TO BE READ

the more familiar aspects of modern urban spaces, such as graffiti and historical changes of use within specific buildings – for example brown-field site developments, the renovation of industrial and commercial buildings for residential or social use and the changes in denomination of religious and secular buildings.

By limiting the information displayed on each map in the series, particular emphasis was given to those aspects of the area usually unnoticed in Ordnance Survey and town street maps: such details included the number of trees and public green spaces, or elements of brick decoration which mark sections of streets built by the same builders within the same period of time. Drawing on wide-ranging theories from the Situationists (the 1960s avant-garde art movement whose models of psychogeography were both an art

practice and a political statement), together with those from sociology, geography, architecture and design, Barnes endeavoured to develop a methodology for mapping everyday life and space; to create maps of meaning rather than 'skeletal landscapes of statistics'.

One striking implication of this method is the possibility for the viewer to combine maps which give specific information in order to read the interrelationship between the two: the relationship between green areas, parks or trees and instances of graffiti for example. Barnes is careful not to guide the reader toward specific conclusions which might be drawn from this exercise, the emphasis is always on the social use of the space, rather than its simple physical features.

This notion of a human geography is particularly

A detail of one of a series of maps produced by Alison Barnes (opposite). In this map Barnes has typographically charted the graffiti in New Basford, Nottingham. The detail shows the nature of the graffiti, tags and insults displayed street by street in the area. The inset detail shows the map in its entirety.

'"The map is not the terrain," the skinny black man said.

"Oh yes it is," Valerie said. With her right hand she tapped the map on the attaché case on her lap, while waving with her left at the hilly green unpopulated countryside bucketing by: "This map is that terrain."

"It is a quote", the skinny black man said, steering almost around a pothole. "It means there are always differences between reality and the descriptions of reality."

"Nevertheless," Valerie said, holding on amid bumps, "we should have turned left back there."

"What your map does not show," the skinny black man told her, "is that the floods in December washed away a part of the road. I see the floods didn't affect your map."'

Denis Wood, The Power of Maps (Guilford Press 1998)

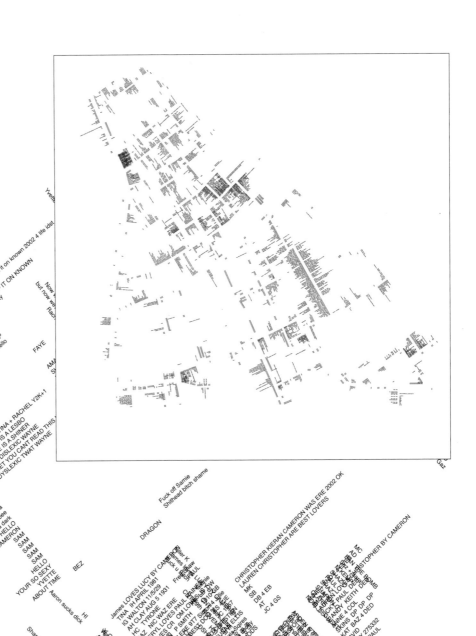

important within one map in the series, which is based on the oral testimony of four elderly local people in a local residential home. Barnes interviewed them and documented their memories of the places where they used to live, work and socialise. The resulting colour-coded map shows the locations that each person described, and allows the reader to interpret any overlaps in those places used as social space (for example work, shopping or leisure), together with those that might be described as personal spaces (homes, gardens and birthplaces, for instance).

Maps are an accepted part of everyday life and, for most people, they are simply a graphic representation of space, regardless of whether they deal with road systems, populations, or natural features of the landscape. They have become embedded in society as an unquestioned truth, a reality — they have become the territory. However, the territory, its inhabitants and their behaviours are inevitably more complex than conventional maps illustrate.

As Barnes asks: '...can it ever be possible to really map a space, reflect the true nature of the landscape (clearly this implies something more than just physical representation) and convey a real sense of the everyday life of users of that space?'

The maps created by Alison Barnes are intended to work both independently and in parallel with each other, to display the interrelationship between different aspects of human and physical geography.

The diagram opposite was created early on in the development of the project as a brainstorming exercise, with the intention of cross-relating those research areas which might overlap. Maps which chart the instances of graffiti in the area, for instance, are juxtaposed with the notion of topophilia – the care and attention given to a property by its owners.

This detailed plan for the project allowed the designer to investigate a wide range of overlapping themes, whilst relating them to each other in the project methodology. The central 'base map' could be described as closest to a standard street map, as it detailed architectural spaces, highways, public and residential buildings.

However, even here there was room for alternative approaches. Barnes's maps of residential and commercial property included colour-coded diagrams of the age of the buildings and information about changes in use, for instance the conversion from light industrial and factory sites to housing and retail spaces. When combined with information about graffiti or oral histories, a far more complex and human picture of the environment can be developed in the reader's mind.

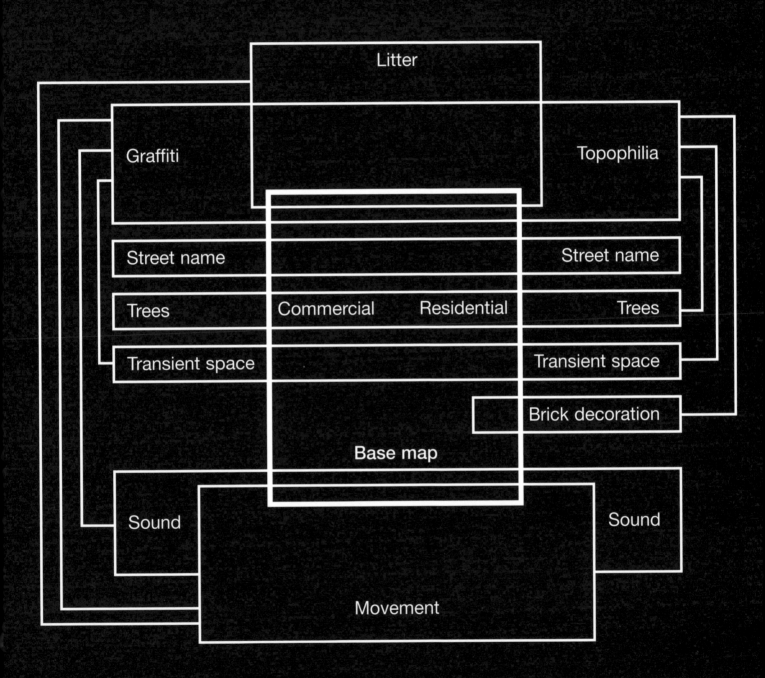

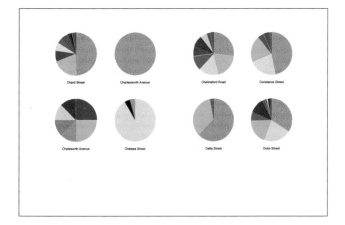

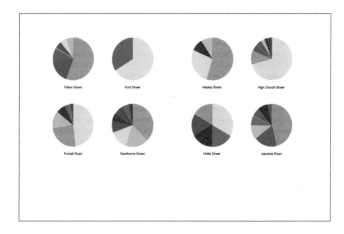

Spreads from a series of publications made by Alison Barnes as part of her research into the New Basford area (above and opposite). The spreads above show how Barnes has used bar and pie charts to designate a range of information relating to the proliferation of graffiti and tagging in each street.

The pages shown opposite (top) demonstrate the detailed records of the types of graffiti and the genealogies that Barnes created to help in her analysis. Barnes also represented the information to show the extent of the graffiti street by street. The pages opposite (bottom) show the analysis Barnes made of the decorative brickwork of the buildings in the area.

This approach to the use of the tools of visual communication and information design has been described as visual journalism, indicating not only how graphic design can be applied to wider social situations, but also to a personal position regarding the role and function of the graphic designer. While the traditional roles of the designer remain, new debates and discussions within the profession are beginning to offer possibilities for designers to explore more personal interests and reflections within their work.

Attraction/Admiration/Ego

J 4 EVA
Joanne 4 nobody!
Joe 4 Kelly
John 4 Zoe
John is so cool
JO LOVES LEE T
Josephine 4 Guy
JOSH 4 EVA
JM LOVES MT
JM LOVES SM
JP LOVES OL
JT LOVES GB
KANE IS GOOD
Kathleen LVS Pete
Kaydawn 4?
Kaydawn 4 Jamie
Kaydawn 4 Nathan
Kaydawn M 4 Nathan
Kaydawn 4 Nathan
KELLY 4 DANNY
Kellie 4 Robbie
Kelly Meashawn 4 Robbie
Kerry 4 Gareth
Kerry loves Rich
KHALAS CREW RULE OK
KIERAN LOVES AMY
Kim loves Russ
Kim S loves Max H L.A.S.T
Kirstie likes ?
Kirstie 4 Martin
KITTYS STREET OK
Kym + Nathan
LAUREN CHRISTOPHER ARE BEST
LOVERS
LAUREN IS NICE
LAUREN IS THE BEST LOOKING GIRL
IN BASFORD. She has a bum button love
Christopher and Cameron

Attraction/Admiration/Ego

LAUREN LOVES CHRISTOPHER BY
CAMERON
Leeann 4 ?
MJ 4 JJ
LIAM LOVES JOSE
LINDSEY IS SEXY BY BH
LINDSEY IS SEXY BY BH
LISA 4 BARRY
Lisa 4 Dwaine
Lisa 4 Jamie
Lisa 4 Simon
Lisa LVS Dwayne
Lloyd is fit by Becca
Lloyd is FIT 100%
Lloyd is sexy
Lloyd is sexy 100% fit by Becca 4eva
LM 4 MW
LORRAINE 4 RYAN
LOU LOVES ?
LOVE
LP LOVES RC
LR LOVES SM
Lucy is Beautiful By Noone
Lucy LVS ?
Lucy LVS Cameron
LUV PAUL
M 4 AI
M LOVES A
Magiz luvz Nelly 4 ever
MARCUS + BECCA 9T4
MARIJANA 4 EVER
MARTIN LOVES LORRAIN
MC LOVES ?
Michelle 4 ?
MICK 4 CAROL
MM 4 AB
Natalie 4 Gareth
Natalie 4 Ted

Attraction/Admiration/Ego

Nisa 4 Tom
NOEL IS GREAT
OM LOVES JS
Paul is the best
PB 4 JO
PETE 4 CAROL
Peter is funky
PR 4 JS
PR LOVES PL
R 4 ACHOPER (SAMMY)
R 4 C
R 4 L
RA 4 CLAIRE
RD LOVES ?
RF 1935 LOVES JK
RH+LJ
Rhonda + Denise 4 Simon
Rissa n Dan 4eva
Rothi lov MANi
RN LOVES SR
R NEAL LOVES G REID
RW LOVES JT
Ryan is Chum
RYAN IS 100% FIT/SEXY
Sapphire loves ?
Sara 4 Chris
Sarah 4 Nicholas
Sarah loves the 3 boys
SB 4 KP
SCOT IS THE BEST
SF 4 SM
Shula 4 Den
Simon 4 Julie
SS 4 KH
SUPA DEE 4 LIFE
Tanya 4 Daniel B
Tanya + David 4eva ldst
TARA 4 SCOTT

Attraction/Admiration/Ego

TOGGS LOVES P
Tom is fit
Tracey 4 Scott
Tracey loves Jason
Tracey loves Jason
Tracey + Kerry woz ere lovin Jason +
Gareth
Tracy 4 Jay
TREV + SANDY
TW LOVES
Vincelle loves Jordan Willy Head
W 4 L
YOUR SO SEXY!
YUGION ruLES
YVETTE 4 Francis
Yvette luvs Francis 4 ever yea yea
Zorena 4 Jad

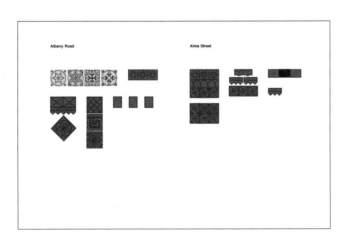

Albany Road Alma Street

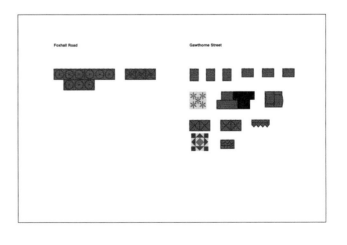

Foxhall Road Gawthorne Street

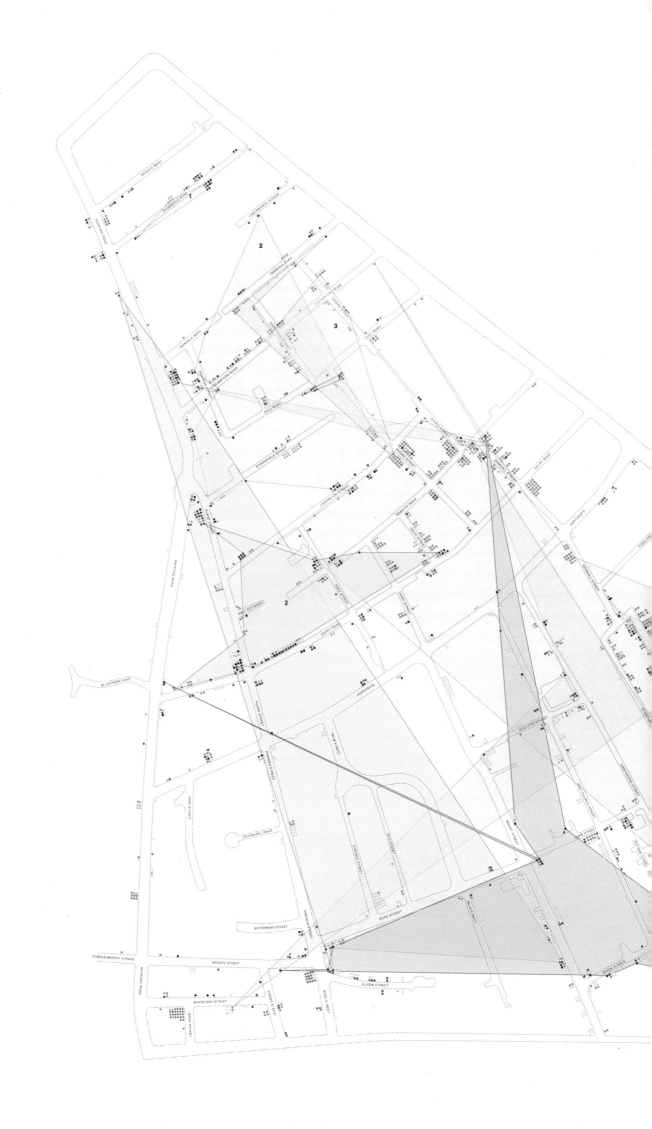

Graffiti territories in New Basford

This map shows all readable instances
of graffiti within the area. The graffiti is
categorised by subjects that are represented
by colours. Those authors (and two subjects)
that appear regularly have been mapped to
show the territory they cover. All mispellings
and use of upper and lower case are direct
transcriptions of graffiti.

Key

Subjects

- ● I was here
- ● Sex
- ● Politics
- ● Music
- ● Expletives/threats without direction
- ● Name/Initials
- ● Attraction/love/ego
- ● Football
- ● Film/TV
- ● Insults
- ● Tag
- ● Friends
- ● Miscellaneous
- ● Brands

Territories

1 Insults towards Wayne

Zulu Road
Wayne is a muff licker
Wayne is a cunt
Wayne is a muff
Go fuck your mum up her arsehole Wayne
Wayne is a cunt

Ekowe Street
I BET U CANT READ THIS U DYSLEXIC
TWAT WAYNE
KILL DISLEXIC WAYNE
WAYNE IS A SHINER

**2 Jamie, James,
Daniel and Tom**

Eland Street
JAMIE is The best
James Chaplin is a fucking dick by ?
James is gay

Liddington Street
Tom is a mother fucker
Tom is a bitch
Tom is a ho
Jamie is gay with Daniel
Tom is gay with Jamie
Tom is a nob fucker

Suez Street
TOM IS GAY WITH JAMIE G

Rosetta Road
Jamie is gay by Kirby

Egypt Road
Jamie
Daniel + Daniel + Dean
Daniel/Paul D is gay
James + Daniel woz ere Y2K+2
Lou + Emma + Dan + Little David + Ste woz ere Y2K+2
Emzy + Dan + James + Jamie + Paul woz ere Y2K+2
Daniel is gay and so is his brother

⬜ Left wing politics

Radford Road
RESIST THE WAR

Rosetta Road
BAN THE BOMB

Mount Street
REGIME CHANGE BEGINS AT HOME
PEACE

Duke Street
NO MORE MASTERS NO MORE KINGS!
FIGHT WAR NOT WARS
DESTROY POWER NOT PEOPLE
NO TO WAR WITH ARGENTINA

Mosley Street
NO BLOOD FOR OIL

Rawson Street
NO TO THE WAR

Beech Avenue
BUSH! HAVE A BREAK HAVE A PRETZEL
STOP DA WAR
ANARCHY

Foxhall Road
LIFE IS CRUEL ALL ARE GUILTY!

Gawthorne Street
STOP DA WAR!!!

⬜ Foot fetishist

Radford Road
I WANT 2 SUCK UR TOES GIRLS!! TXT:
07754 948025
I WANT 2 SUCK SEXY SCHOOLGIRLS TOES!!!
07754 948025
I WANT SEXY SCHOOLGIRLS FEET!!!
07754 948025
! SUCK GIRLS TOES!!! (07754 948025)

Duke Street
I WILL SUCK YOUR TOES BITCH!!! AN

Elson Street
I CUM Allover a Picture of Kylie Minogues Sexy
Feet!!! By AN

Mount Street
NICE SHOES CUTE FEET 07754 948025
SUCK MY BIG COCK LITTLE GIRLS IN SANDALS
07754 948025

1 Kim and Kirstie

Silverdale Road
Kirstie likes ?
Kirstie 4 Martin
Kim N Kirsty woz ere!
Kim + Kirsty B.M.F.M
Kim is gay
Kim loves Max H L.A.S.T

**2 Lauren, Cameron, James,
Lucy, Christopher and Kieran**

Chatsworth Avenue
Lauren is my best friend now and forever

Isandula Road
LAUREN U WHORE
Cameron U DICK

Pearson Street
Lauren is a bicth

Chelmsford Street
Ring me 01909 474774 for bitch Lauren

Radford Road
CAMeron is gay
Christopher is a ho by ?

Springfield Street
Cameron u Batiman
Lucy LVS Cameron
Lauren u whore

Liddington Street
James loves LUCY BY CAMERON
Cameron
Cameron
Cameron is a dick

Ekowe Street
CAMERON

Suez Street
Kieran
Christopher is gay

Gawthorne Street
CHRISTOPHER LOVES LAUREN OK

Constance Street
KIERAN LOVES AMY
AMY LOVES KIERAN
JAMIELEY LOVE KIERAN
CHRISTOPHER LOVES LAUREN BY CAMERON
Lucy is Beautiful by Noone

Monsall Street
LAUREN LOVES CHRISTOPHER BY CAMERON
LAUREN IS THE BEST LOOKING GIRL
IN BASFORD she has a bum button love
Christopher and Cameron

Chard Street
LAUREN CHRISTOPHER ARE BEST LOVERS
CHRISTOPHER KIERAN CAMERON WAS ERE
2002 OK

3 Kitty and Jubee

Isandula Road
Jubee
Kitty
Jubee + Mary
Kitty Jubee woz ere 2002

Durnford Road
KITTY + JUBEE
JUBEE
KITTY'S STREET OK

Ekowe Street
Kitty
Jubee

Chard Street
Kitty
Kitty keep it onknown 2002 for life idst
Kitty + Jubee 4 life Dont Hate us Conguralte us

4 Yvette and Jade

Chelmsford Road
Yvette + Jade

Rosetta Road
Yvette
JADE JOHNSTONE

Ekowe Street
Yvette

Monsall Street
Jade luvs herself 4 ever
JADE
YVETTE
JADE
YVETTE
JADE
Jade

Sandon Street
Jaurdan + Jessica + JADE + Rasheena + Akilah woz
ere 29.11.02 Y2K
Jade + Rasheena + Cherniece + Hayley woz ere

Shipstone Street
Yvette

Maud Street
Yvette + Margaret + Jessica + Jade

Radford Road
Crystal + Sapphire + Jewel + Jade woz ere

5 Leeann, Becca, Dan and Lloyd

Monsall Street
Leeann woz ere 01
leeann

Wycliffe Street
BECCA + DAN
Lloyd is fit 100%

Sandon Street
Lloyd is sexy
Lloyd is fit by Becca

Maud Street
Leeann woz ere 01
Leeann woz ere 01
Leeann + Callum + John + Harley woz ere Y2K2
Leeann + Rebecca
LEEANN WOZ ERE!
Leeann + Becca
Lloyd is sexy 100% fit by Becca 4eva
he is a dickhead by Becca
Hello my name is leeann
Lan + Bec
Leeann + Becca
Leeann + Becca
Leeann + Becca
Leeann + Becca
Leeann
Becca 4 ?
Leeann 4 ?
Becca 4 ?
Leeann + Becca
dan and Lan are dan
Leeann + Rebecca woz ere 2002
Leeann wos ere 2002
LEEANN + DANIELLE + CHELSEA + REBECCA
Leeann is gay
Leeann is gay
Leeann
Leeann
Leeann
Leeann
Leeann

4

BEECH AVENUE

Case Study 03: I Love You

Graphic designer Wayne Daly has investigated the relationship between graphic design and human emotions in his personal project entitled 'I ♥ ♥' (based on the famous I ♥ New York device). In response to US-based Austrian designer Stefan Sagmeister's claim that he wanted to *'make design that would touch people's hearts'*, Daly began to explore the history and context of the love-heart symbol and its cultural applications.

The resultant series of posters document not only the history and development of the symbol itself but also its wide implementation in brand and corporate identity. Posters were designed to break down the information gathered in a number of ways: as a typology of the graphic symbolism of the heart and of love, divided into categories representing figurative or

Featured here and on the following pages are examples of designer Wayne Daly's project exploring the visual aspects of the notion of love. Daly explores the history and development of the love-heart symbol, together with the ways in which it has been employed as corporate or product identity in what he calls a heart typology.

Typology
In simple terms the phrase refers to the study and interpretation of types – a person, thing or event that serves as an illustration or is symbolic or characteristic of something. In relation to the work shown here, the phrase relates to the organisation of types and their classification for the purpose of analysis. This method of working as part of a research project could also be described as analytical research – in that it examines quantitative data and allows a comparative analysis to be made between types or characteristics of types. Used here by Wayne Daly as part of the final outcome in his research into the language, use and history of the love-heart symbol, the work constitutes a form of information design. Daly's work is concerned with the idea of graphic design as an action or intervention – which could also be termed action research. A large part of his approach to the project was to create events which he took an active role in.
He then used the visual language of information design to make a series analysis in the form of typologies which are presented as part of his overall documentation of these acts and the reflection upon them.

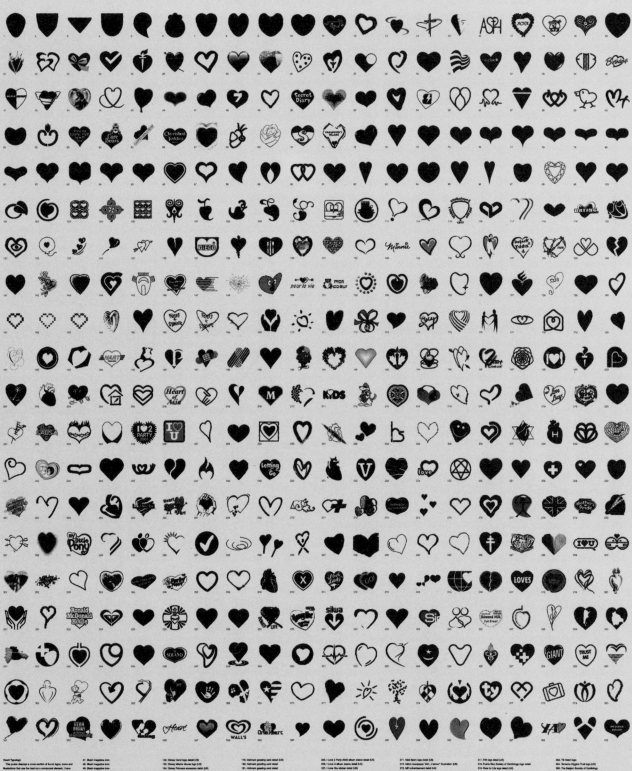

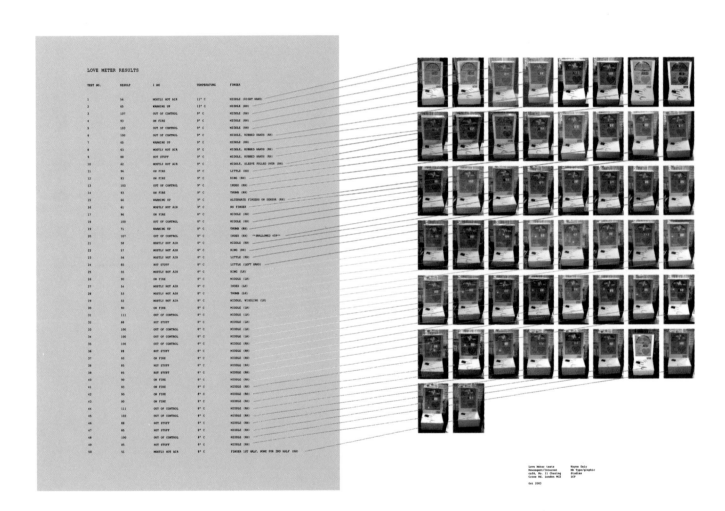

Love Meter tests
Newsagent/Internet
café, No. 11 Charing
Cross Rd. London WC2

Oct 2003

Wayne Daly
MA Typo/graphic
Studies
LCP

Further typology matrices were developed by Daly in order to display a wide range of interpretations of the information. The matrix shown opposite shows the range of products and services associated with the companies and groups whose logotypes are derived from the heart symbol, from charitable bodies (orange) and healthcare (green) to political groups (red) and pornography (light blue). Through the creation of a series of typology matrices, the designer is able to display a range of interpretations of the ways in which the heart symbol has been utilised and adapted throughout the history of graphic symbols.

Daly's project also explored a number of other strategies relating to love, including a study of lonely hearts advertisements in newspapers and the polling of passers-by in the street. The designer's personal interest in cheap mechanical reproduction and the 'ghost in the machine' also came into play in a number of ways. The project shown above charts the responses gained by Daly through a series of visits to a fairground 'love meter' machine, which purports to measure the user's levels of love and desire.

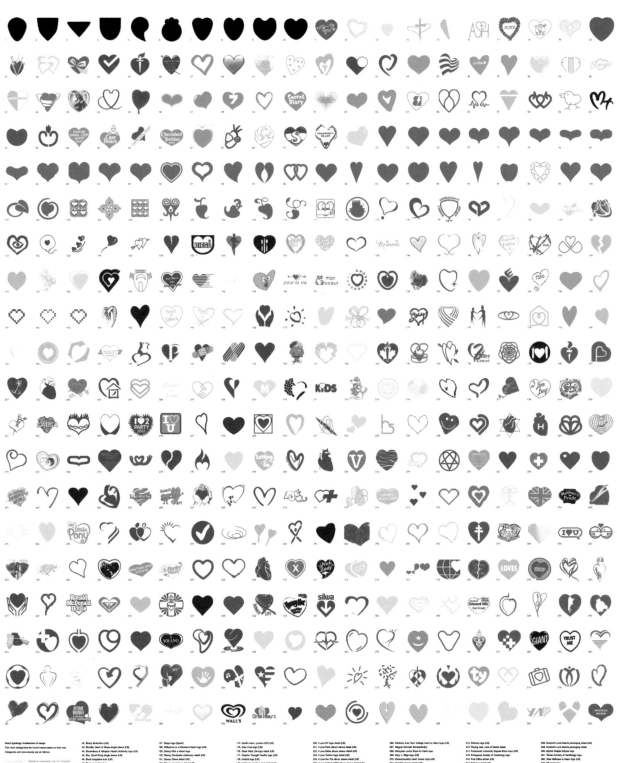

metaphorical usage, and the historical evolution of graphic representations of the heart. Some uses of the graphic device are iconically linked to their subject – for instance in the logos of medical organisations and cardiac charities, whereas other instances simply incorporate the sign as a visual symbol. The relationship between form and colour also provides an interesting area of further study.

Daly also engaged in a series of explorations of other visual forms that involve the notion of love. These involved a range of activities such as the creation of a project based on the analysis of lonely hearts advertisements in newspaper columns. This project saw Daly making a detailed study of the specific vocabulary of such advertisements, leading to a quantitative analysis of the most frequently used words and acronyms, then placing generic adverts back within the

same publications. Other parts of the project centred on Daly's personal fascination with mechanical reproduction and the 'ghost in the machine'. This included the detailed study, and mapping of, results of an arcade slot machine which apparently measures the user's romantic disposition, and the use of an internet based language translation programme to develop the phrase 'I love you' through several languages in a series of accumulated errors and mistranslations.

Daly's project was developed into a range of separate outcomes, all linked by the initial theme of the graphic language of love. The resultant work was then combined within a project document and presentation which charted the series of investigations conducted throughout the duration of the project.

Part of the contextual research conducted by Daly involved the collection and categorisation of

a massive range of graphic ephemera relating to love and to the heart symbol, all of which was scanned and arranged within a publication marking the overall scale of the project (opposite).

→IN THE

Structuralism

BEGINNING

Semiotics

WAS THE

Saussure and Peirce

WORD←

According to the Swiss linguist Ferdinand de Saussure, language can be understood as a system of signs. In a series of lectures (the *Course in General Linguistics*), delivered at the beginning of the last century and published posthumously in 1915, Saussure proposed that the basic unit of any language is a sign or phoneme. A sign is made up of a signifier (an object) and a signified (its meaning). For example, the word *bicycle* functions in the English language by creating the concept, or signified, of a mode of transport — a machine with two wheels that is powered by its rider and which is used for travelling from A to B. The relationship between the signifier and the signified is arbitrary. There is no logical or natural connection between the spoken sound or graphic representation and the concept of bicycle (this is known as duality). The connection or relationship is established solely in its use by English speakers.

Saussure was ultimately concerned with the structure (*langue*) rather than the use of language (*parole*). This analytical way of thinking about the structure of language and meaning became known as structuralism. The basic unit of this structure, the sign, only has meaning because of its difference from other signs in the same system — the *langue*.

The study of signs is also known as semiotics — a term coined by the American philosopher, lexicographer and polymath Charles Peirce. His theories relating to language, logic and semiotics were developed during the same period as Saussure's. Peirce was concerned with the world we inhabit and how we use language and signs to understand this world. Peirce states that there are three principal kinds of signs: iconic signs, indexical signs and symbolic signs. Iconic signs are likenesses that convey the idea of the thing they represent by imitating them — such as a photograph of something. Indexical signs convey information by 'indicating' their physical connection with the thing they represent, such as smoke to fire. Symbolic signs are general signs that have become associated with their meanings by conventional usage.

VISUAL RESEARCH

THEORETICAL AND PRACTICAL MODELS

THE DECONSTRUCTION OF VISUAL WORK AND THE DEVELOPMENT OF NEW DESIGN STRATEGIES AND METHODS

Visual Research

Visual research covers two main themes when related to what might be termed analytical and propositional methods – the deconstruction of existing visual work and the development of new design strategies and methods. In order to develop tools for the analysis of design objects and artefacts, it is necessary for the designer to become familiar with terminology borrowed from a range of disciplines outside of the traditional role of the graphic designer. Some of these terms might be introduced to the design student as part of their wider cultural studies programme, but are often kept distinct from the range of practical activities within the design studio itself.

However, it is important for the designer to understand the vocabulary associated with the analysis of texts – by which we mean both visual and textual forms of communication – in order to reflect more clearly on the decisions made within their own work. As discussed in the previous chapter, it is useful for the designer to break down this activity into a series of interrelated stages, mapping on to the basic principles of field of study, project focus, methodology, technology and materials. The terminology used in the analysis of texts might be replicated in the description and construction of new material in order to qualify the intention of the designer more clearly: this can be seen as the shift from analysis to proposition.

Both qualitative and quantitative methods of design analysis might be necessary to conduct a thorough study of a piece of visual communication, either through decoding meanings in individual artefacts or through the collection and comparison of a range of related examples in order to evaluate design

Denotation and Connotation

A particular word or a sign may have a literal meaning – this is called denotation, and it will also have a connotation or range of connotations.

Whilst denotation could almost be described as obvious or common sense in its literalness 'this is a photograph of two men talking and smiling', connotation refers to the range of cultural, social or personal interpretations of a sign, image or word (the two men in the photograph are brothers, in love, businessmen making a deal etc.). How the photograph is printed, in soft focus or grainy and black and white for example, will also generate interpretation and influence how the reader understands the image (see Materiality, page 143).

In the science or art of semiotics (see pages 88–89) denotation and connotation relate to the relationship between the signifier and the signified. How the connotative meaning of an image or a sign, for example, is understood by the 'reader' becomes an analytical tool and also forms the basis of a useful strategy for the graphic designer.

The understanding that visual messages can be treated as 'open texts' (see Text, pages 98–99), and that their connotation is based upon the interpretation of the reader on the basis of their class, gender and education is known as polysemy.

These images (this page and opposite) are a range of signs that we recognise as denoting *birds*, but all also have individual connotations.

vocabularies selected as appropriate to a particular context or audience. Visual research involves the designer in a broad range of activities, which contribute to the development of new design propositions in a number of ways. Firstly, the designer needs to understand the context within which the work is to be placed. This means that the range of materials already in existence within that context, the expectations of the target audience and the existing messages against which the work may be required to compete all need to be taken into account.

Traditionally, design education has worked with contextual visual research at the level of materials gathering and the construction of 'mood boards' – rough layouts of a range of objects which relate to the message, giving an impression of the kind of 'feel' intended by the designer at the outset of the project.

Some of these objects and visual elements might relate directly to the envisaged resolution, whilst others are incorporated to denote emotional aspirations and the underlying feelings which the product is intended to evoke. While this can be a useful exercise, particularly in relation to product design, advertising and marketing, graphic designers also need to develop a more sophisticated methodology for analysing a range of materials relevant to the proposed project.

It is important for the designer to understand the range of visual languages and texts which already exist in the space that the proposed design will occupy. All audiences have expectations with which they interrogate and interact with visual messages – the aim of innovative design is to relate to these already familiar forms, and to extend the visual language used in new and exciting ways. In simple terms, this means

Sign, Signifier and Signified
Language can be understood as a system of signs. Ferdinand de Saussure proposed that the basic unit of any language is a sign or phoneme. A sign is made up of a signifier (a sound or image) and a signified (the concept or meaning). The relationship between the signifier and the signified is arbitrary. There is no logical or natural connection between the spoken sound or graphic representation and the object

itself (this is known as duality). The connection or relationship is established in its use by English speakers. Saussure was concerned with the structure (*langue*) rather than the use of language (*parole*).

This analytical way of thinking about the structure of language and meaning became known as Structuralism. The basic unit of this structure – the sign – only has meaning because of its difference from

other signs in the same system – the *langue*.

The study of signs is also known as semiotics – a term coined by the American philosopher Charles Peirce. His theories related to language, logic and semiotics and stated that there are three principal kinds of signs: icons, indices (or index) and symbols. Icons are likenesses that convey the idea of the thing they represent by imitating them –

such as a photograph of something. Indices or indications convey information by their physical connection with the thing they represent. Symbols are general signs that have become associated with their meanings by their use and convention.

With thanks and acknowledgement to Rolex

The two logos (signs) featured here employ the same associations but are at different ends of the value system in most western societies. Both of the corporations – Rolex, in a visual manner through the use of the crown, and Burger King, in its title (the signifier), make reference to royalty and monarchs. The signified at work here is the association we might make with luxury and status. Whilst one could argue in terms of what Rolex produce that a watch is just a watch, a Rolex timepiece has become synonymous with luxury and is regarded by some as a status symbol because of the quality and the expensive price tag. Burger King operates at a different level – no matter how tasty, nutritious and good value one might consider their food to be, it would be difficult to argue that owning a Burger King meal made an individual part of an elite or exclusive 'club'. The reference to monarchy in the title (the sign) could be either aspirational or used to suggest that the company is the king of burger makers and by extension its food is better than all other burger makers (the signified).

Visual Research

that the form of the visual language carries meaning, before we even start to analyse the content of the message itself. As Marshall McLuhan succinctly put it in his 1967 manifesto, *'...the medium is the message'* – in other words, the ways in which we transmit and receive information has an important and direct effect on the content of that information and the ways in which that content is read and understood.

A colloquial way of making this point might be the phrase 'first impressions count' – our first encounter with a visual form gives an instant impression and level of expectation. Once we have seen the initial visual form, we anticipate at least a part of what we expect to see or hear next. This principle can be seen at work in contemporary film, for instance, where the director can move smoothly between shots and points of view in order to establish a narrative structure, or can cut to an

unexpected frame in oder to create elements of surprise, shock or humour. As the linguistics theorist Roman Jakobson has stated, *'the message does not and cannot supply all the meaning of the transaction, [and] ...a good deal of what is communicated derives from the context, the code, and the means of contact. Meaning, in short, resides in the total act of communication.'* Audience expectation is a key factor in the development of successful design solutions, and in the exploration of new forms of visual communication based on dialogue and audience interaction, themes which will be explored further in Chapter 4: Audience and Message.

Contemporary graphic design is not always concerned with problem solving, or operating in relation to a client's brief. The exploration of a theme that interests the designer, and the graphic response to that theme

Text

The use of the word text refers to more than the printed word on a page in a book. It also encompasses a range of other activities and items related to cultural production. This would include for example a film, a wrestling match on television or a building – anything that carries meaning and that could be 'read' by an audience.

In the late 1960s and early 1970s the French philosopher

Roland Barthes began to challenge the existing idea that the author of a book could be considered as the central and controlling influence on the meaning of a text. In his essays *The Death of the Author* and *From Work to Text*, Barthes argues that whilst it is possible to trace the influence of the author in a text, the text itself remains 'open', encouraging the idea that the meaning is brought to an object – particularly a cultural object –

by its intended audience. In this way, the meaning does not intrinsically reside in the object itself and cannot be reduced to an authorial intention.

Barthes related *The Death of Author* to *The Birth of the Reader*, claiming that *'a text's unity lies not in its origin but in its destination'*.

which might enlighten and help to describe new visual languages that are applicable to other graphic solutions, is a core part of the research agenda. In effect, this places the design methodology itself as a central component of the design process. The testing and development of a visual vocabulary relevant to a specific context may then be further developed in order to address a number of problems within that same context. The resultant 'solutions' can then be drawn upon by the designer in relation to further practical and commercial work.

It is important at the outset, however, for the designer to establish a clear set of intentions for an individual project and a critical position, relative to the subject being explored, so as to be able to reflect on progress made and to test the resulting graphic messages against a set of stated criteria – in effect, replacing the client's brief with one of the designer's own creation. The resultant design propositions are then both a combination of the personal exploration of the subject and a nascent visual language that operates within a set of predetermined objectives.

Case Study 04: Full English

The self-initiated project 'Full-English', by editorial designer Sharon Spencer, explores the notions of Englishness and English identity. The designer was interested in creating a graphic language of Englishness, choosing to concentrate on a content-led approach, and developing pictorial icons that capture essential aspects of nationality and the changing notions of English identity in the 21st century.

Spencer's initial research looked into the ways in which such a concept has been treated historically – in literature, song lyrics, fine art and photography for example. These explorations covered a diverse range of topics and media, from the poetry of Wordsworth and the prose of Shakespeare to the paintings of Constable and Turner and the contemporary song lyrics of The Kinks, The Clash and Morrissey. Although much of this research yielded a wide range of results, the concept of a distinct English identity was, in fact, made more opaque. Poetry and song lyrics tended to rely on colloquial gestures and loose indications often buried within the subtleties of the spoken (or sung) English language, whilst images often led towards those visual clichés of tradition and empire. Spencer was keen to update some of these visual metaphors in order to reflect the day-to-day reflections and tensions inherent in the modern English identity.

Graphic influences on the project encompassed a range of material including Jonathan Barnbrook's Virus Foundry font Apocalypso, Martin Parr's documentary photography and the ISOTYPE pictorial sign system. Barnbrook's Apocalypso – an image- and symbol-based typeface – is intended to operate as a conceptual vehicle for the designer's anti-war sentiments and

A selection of individual icons from Sharon Spencer's pictorial alphabet of Englishness (opposite). Spencer chose to explore this personal area of interest using the language of icons and ideograms more usually associated with international signage systems.

By adopting an approach based on symbols which are usually accepted to have commonly understood and singular meanings, she begins to explore the process of interpretation at work in language and communication.

Starting with a range of stereotypical icons of English identity, such as the mock Tudor cottage, the village church and the policeman's helmet, Spencer went on to develop more contemporary icons which reflect current media concerns and the changing face of the nation: security cameras, mobile phones and modern farming techniques mix with seaside deckchairs, garden sheds and terraced houses.

antipathy towards official propaganda rather than serving as a traditional, functional font. Meanwhile, the contemporary photography of Martin Parr – in particular his revealing images of the English relaxing and on holiday – served as an influence for the eventual presentation of the project in book form.

Spencer's research also focussed on the ISOTYPE symbol system developed in the 1920s and 1930s by husband and wife Otto and Marie Neurath. Also known as the Viennese method, ISOTYPE (International System of Typographic Pictorial Education) employed pictorial signs to illustrate charts, diagrams and books related to economic and educational information. This influential system and approach to information design was significant because the Neuraths represented numerical mass in diagrams by the repetition of identical sized symbols rather than through the use

of scale, avoiding the perspective that would have involved differing sizes of symbol to create the visual effect of distance.

This contextual background research provided the basis for Spencer's approach to the project. The initial development was of a proposal for a symbol-based font that was programmed to respond to individual keystrokes on the computer keyboard and worked across three layers. Each layer related to the main keyboard using the standard, shift and alternate functions of the 'QWERTY' layout. Keystrokes could then be interrelated to show the narrative development of a concept.

The system of symbols created constitutes a personal graphic lexicon in which Spencer chose to comment ironically on themes of prejudice, social and political

These images (opposite) are spreads from the book produced by Spencer as part of the Full English project. Across the sequence of pages Spencer utilises the individual icons she designed to explore their narrative possibilities in combination with each other.

In this respect the icons may contain singular meanings, such as in the symbol of a house, but when placed in combination in a linear

sequence begin to make ironic comments on status and property-owning in England. Whilst the icons offer individual interpretations of the same theme (individual styles of houses for example), they all represent the concept of house or home.

Spencer has also employed her own photographic images within the book. These are designed to provide a visual counterpoint to the icons and

also to provide a context which allows the viewer to read the symbols in a similar fashion to text in a more traditional book.

issues, the significance of class in English culture, greed, consumerism and taste. In many cases Spencer documents the range of ongoing debates within the national press and media during the last decade. The font used presents a particularly unromanticised view of Englishness and comments upon a number of present day national social concerns, such as housing and homelessness, genetically modified foods and media-fuelled anxieties surrounding asylum seekers and football hooligans.

Whilst it is possible to critique the success of the symbols created by Spencer as 'stand alone' individual icons, it is more significant to contextualise them as related elements of a larger system. It is in the manner that they work together that these symbols operate most successfully. The narrative possibilities of the symbols – their ability, in combination, to tell stories

and create potential meanings for the reader is based on the idea of wordless communication – a central tenet of a specialism of graphic design known as information design or, more recently, information architecture.

Characters in corresponding positions on the three keyboard layers are related. An image, like a word, is culturally specific and has multiple meanings depending on its context. Images can be combined to build new signs, just as words are combined to form sentences. Some of the symbols read as a combination of signs into one pictogram whilst others are grouped into sequences reliant on the natural inclination of the reader to make associations and connections. The individual icons may not originate from England but are regarded as part of English culture, and relationships between the images create a typically

Narratives created by the combination of individual icons within Spencer's system (opposite) show the development of contemporary English identity through the eyes of current and popular media obsessions.

One such obsession is the idea that football is now frequently connected to crime and hooliganism. The football icon (below left) takes on a range of different interpretations when

placed alongside a baseball cap and the security camera.

Other icons attempt to convey complex meanings, in some cases functioning as ideograms rather than pictograms. The female body clock (above left) symbolises the urgency of partnership and motherhood and the passing of time for the modern thirty-something career woman, while the nuclear family (above right) has developed into a range of

family units including the single mother (above centre).

As a system of complex narratives, these symbols are an attempt to build a bigger picture of contemporary life in England, and English identity in the 21st century.

English scenario. Although Spencer leaves the project 'open' for the reader in terms of her implicit intention, her understanding of both her own personal and national identities forms the core of the project.

Whilst she does not seek to pass judgment on the success or failure of contemporary English issues such as government policies on multiculturalism, regionalism and devolution, Spencer's symbol font attempts to show a range of issues within modern English culture in a humorous and thought provoking way.

Further narratives created by the combination of individual icons (opposite) relate more broadly to the range of changing technologies and English food, leisure and lifestyle choices in the 21st century.

The top row of symbols is intended to reflect upon the widespread increase in fast food and takeaway culture, in this instance to the takeaway pizza, which is often delivered by young people on mopeds or scooters. The middle row of icons relates to the evolution of new forms of entertainment such as the widescreen television and games console, placed alongside the couch in order to ironically hint at the parallel development of a more sedentary lifestyle.

The bottom row icons also make humorous reference to changing lifestyles, in the form of bottled mineral water, a large coffee cup and saucer – often found in the new breed of coffee houses on the high street – and the polystyrene takeaway coffee cup.

Shown overleaf are the full set of keyboard layouts produced by Spencer at the end of the project (top: *alt* function keyboard, bottom left: standard keyboard, bottom right: *shift* function keyboard). Although she had developed several hundred individual icons, Spencer chose to work on the narrative possibilities afforded by the keystrokes of the keyboard when the user chooses the *alt* or *shift* key. In the resultant system, individual keystrokes relate to three layers of the keyboard, allowing complex narratives to be read.

RUBBISH THEORY

First proposed by Michael Thompson in his book of the same name, Rubbish Theory relates to **the creation and destruction of value** within man-made objects, cultural artefacts and ideas. As a social scientist, Thompson became interested in the ways in which objects carry an economic or cultural value which diminishes over time, to the point where they become redundant and worthless. However, Thompson noted that some objects then begin to accrue value once more as time goes on – such as antiques, vintage cars and Georgian terraced houses. Objects can then make the journey from a region Thompson describes as **transient** (value decreasing), through **rubbish** (no value) to **durable** (value increasing). When this idea is applied to a house, for example, we can see that a building may have an initially high value, dependent on status, cost and function, which may decrease over time in relation to an expected lifespan, after which it may have little or no residual value and could be demolished to make way for a new building in its place. However, although this obsolescence tends to happen with certain kinds of property (low cost housing built in the 1960s, for example), it is not the case with Georgian or Victorian English town houses, which the estate agent terms 'period properties'. **Durability** is, thus, socially constructed.

The actions of an individual relate to his or her own **world view** – the way in which he or she perceives the world around them, based on his or her cultural heritage, education and experience – and Thompson's theory attempts to draw our attention to the ways in which our understanding of objects is socially constructed and understood. He goes further in refuting the ideals of **transaction theory**, whereby an agreement is implied between individuals transacting over a valued object, based on their range of shared assumptions. Although different, these assumptions are harmonised over time due to each individual adapting their approach and world view in order to achieve better results in their next transaction – which leads to the homogeneous world view (or shared cultural values) of a social group. Thompson argues that this process is, by definition, static in its exclusion of the range of external influences on the individuals involved, and the fact that their *perception* of the results of their actions may be different from the *reality*. These ideas are useful to the producers of transient and durable objects – such as graphic designers – in helping to describe the complex relationship between the cultural artefact and its perceived value.

AUDIENCE
AND MESSAGE

TWO-WAY COMMUNICATION

THE RELATIONSHIP BETWEEN DESIGNER, AUDIENCE AND MESSAGE, AND THE PRINCIPLES OF COMMUNICATION

Audience and Message

Building on the communication theory precepts outlined in Chapter 3, this chapter further investigates the relationship between designer, audience and message, and considers alternative strategies for communicating through both direct and indirect means. The production of design within a social, cultural and political context is further explored, placing both the designer and the audience as co-participants within predefined frameworks.

Any general definition of graphic design and its intentions cannot fail to make reference to communication and audience. In this regard, graphic designers could develop a vocabulary for describing and understanding their working methods through the language and theory of communication studies. Although a separate discipline with a much broader remit than graphic design, communication studies incorporates a series of useful analytical and descriptive methodologies which relate strongly to graphic and visual communication.

Two schools of thought exist within communication theory, the first of which might be described as the 'process school' – an approach to the subject which is concerned with the actual processes of communication. This school highlights the channels and media through which messages are transmitted and by which senders and receivers encode and decode, in particular the setting up of a model of analysis which is concerned with matters of efficiency and accuracy.

If the process of communication creates a different effect from that which is intended by the transmitter, and in the act of doing so a misreading or aberrant

ONE
WAY
→

interpretation occurs, then that reveals a breakdown in transmission, a flawed system or channel. This school of thought envisages a message as that which is transmitted by the communication process (and maintains that intention is a crucial factor in deciding what constitutes a message).

By contrast, the 'semiotic school' is concerned with the message as a construction of signs which, through interaction with receivers, produces meaning. This school of thought views communication as an agent in the construction and exchange of meaning: by using terms like signification (related to the constituent parts of a message), it does not consider misunderstandings to be necessarily evidence of communication failure. Advocates for this model argue that a differing interpretation within the process of communication would validate a position more concerned with the

plurality and unstable nature of messages, and with their perception of an audience dependent on culture and context.

The approaches of these two schools of thought could also be applied to what are often described as the modernist and postmodernist positions within current graphic design practice and theory. The 'process school' of graphic design– modernity and its legacy– is motivated by notions of universality, rationality, the clarity of communication through legibility, neutrality and the grid. This arguably utopian world view, based on form and functionality and a homogeneous process, could be characterised as dealing with absolutes within communication.

By contrast, postmodern approaches to graphic design embrace and promulgate the view of design and visual

Modernism

Many of the early 20th century art and design movements connected to modernism, such as De Stijl, constructivism and the Bauhaus, endeavoured to celebrate functionalism and rationality under the maxim that 'form follows function'. The modernist approach to layout and design in general focused upon the use of white space and sans serif typography that utilised asymmetry. This was driven by an adherence to the grid, based on geometry and the proportion of the page, as a controlling device.

Postmodernism

A movement that grew out of a rejection of the ideas of modernism. Many of the original values of modernism were, by the late 1960s, regarded by designers as dogmatic and only offering a fixed view or superficial style. Postmodernism celebrated a return to earlier ideas of the value of decoration. Rejecting order or discipline in favour of expression and intuition, many of the key progenitors within the field emanated originally from schools such as Basel in Switzerland and later Cranbrook in the US, and were tutored by central figures such as Wolfgang Weingart and Katherine and Michael McCoy. The postmodern lexicon of historical reference, decoration, wit and the ironic employment of vernacular or non-designed elements, such as hand drawn typography, constituted a departure from the rationality of earlier approaches.

WALK DONT WALK

Information and Knowledge

We live within networks of messages, signs, information, and knowledge which produce our experience of ourselves, society, and all that we consider real.

Sadie Plant The Most Radical Gesture: The Situationist International in a Postmodern Age

communication as an important component in the plurality of contemporary culture, and seek to emphasise its role in constructing a matrix of interpretation. Less concerned with broad bands of communication, this approach to the construction and reading of visual communication addresses specific communities, which might be described in social, economic, or geographic terms.

The recognition that designed objects exist within a social structure, and are read by their receivers from a particular cultural perspective, is central to an understanding of audience-specific graphic design. While certain forms of graphic design may offer some claim to the modernist objectives of universality and mass communication, much contemporary design work operates within more limited boundaries. As such, a sense of familiarity with the graphic languages already

understood by the target audience is crucial to the development of effective design solutions.

Both qualitative and quantitative approaches are useful here, in the collection and analysis of a range of visual material operating within the same space as the intended message. A qualitative analysis of existing artefacts, through the semiotic principles of connotation and denotation discussed in Chapter 2: Methods, can help the designer to interrogate the underlying principles within effective visual messages targeting the same audience. Meanwhile, quantitative methods for reviewing and analysing a broad range of objects in the same space, and gathering feedback from focus or survey groups, can help to create a bigger picture of the range of cultural readings and messages already in place. Knowledge of existing material with which the proposed message will

Quantitative analysis

Quantitative analysis is based on mathematical principles, in particular statistical methods of surveying and interrogating data. By generating a batch production of visual forms to test, the designer can place these objects in specific locations in order to 'count' positive and negative responses from a target audience. This could mean conducting a survey within the target audience group, perhaps with multiple choice questions devised to score against a set of criteria. The data gathered can then be analysed statistically to find the most successful visual form.

Qualitative analysis

Qualitative analysis is based on subjective responses to visual forms and the reading of graphic material by a viewer. Often this is done by the designer him- or herself, in the form of critical self-reflection.

The reading of images and visual signs through semiotic analysis is, however, a qualitative act in itself: although the responses can be evaluated statistically as a form of quantitative analysis, the initial data gathered is based on human reaction to the visual forms and experiments presented.

compete is crucial to the development of a successful design solution.

It is also important to consider the relationship between designer and client, and between client and audience, as well as that between designer, designed object and audience. It should be noted that the designer may play only one part within the creative team involved in a project whose members may range from marketing consultants to copywriters. This is an area that is sometimes overlooked but the relationship and process of negotiation between client and designer is a key development in the definition of the brief itself. Sometimes, the client may be unsure of the best way to target a particular audience, or may be unclear as to the specific intentions of the message itself. In this case, the designer can play a central role in revising and defining the brief in order to address

specific needs and provide a practical solution for the client.

Within commercial practice, the need for this kind of negotiation may mark the distinction between the <Context-Definition> and <Context-Experiment> areas of research mentioned earlier. <Context-Definition> may be appropriate where the client has a good knowledge of their market or audience, and the brief might reflect this by being strongly prescriptive in the range of activities expected of the designer.

Where the client is unsure of the specific problem to be addressed, the <Context-Experiment> model could help to refine the project. In this case, the designer's initial research can help to inform the direction that the project will take, and the process of negotiation between client and designer is foregrounded.

<Context-Definition>
Initial work in this model usually involves a thorough analysis of a broad range of secondary research, mapping the territory to be investigated and determining the range of work which has already been done within the target context.

Once a solid understanding of the context has been reached, the focus for the project can be determined, and a working methodology defined. Primary research is usually beneficial at this stage, in the form of direct surveys of target audiences and visual experimentation to test appropriate visual languages.

The results of these preliminary visual and contextual experiments can then help to define the specific project intention, together with an appropriate methodology which allows the testing of a range of potential outcomes.

<Context-Experiment>
Initial work in this model usually involves looser mapping of the territory to be investigated, an analysis of the range of work which has already been done within the same context, and a specified intention for the work within this context.

The focus for the project needs to be determined earlier than in the <Context-Definition> model, particularly through the definition of what the designer, and the client where appropriate, wishes to achieve.

Distinct visual experiments to test appropriate visual languages and strategies are then conducted in order to determine a range of potential solutions. It is important that an overarching strategy is employed by which to critically reflect upon and evaluate the relationship between each individual experiment.

What is Theory?

The word 'theory' comes from the Greek word 'theorema' meaning to review or to reflect. The dictionary defines theory as an explanation or system of anything: an exposition of the abstract principles of either a science or an art.

Theory is a speculation on something rather than a practice.

David Crow Visible Signs – An Introduction to Semiotics

History meets Theory

The citizen – artist – producer is not the imperious master of systems of language, media, education, custom and so forth: instead, the individual operates within the limited grid of possibilities these codes make available. Invention and revolution come from tactical aggressions against this grid of possibilities.

Ellen Lupton & J Abbott Miller Deconstruction and Graphic Design: History meets Theory

Audience and Message

Contextual research conducted by the graphic designer can then both inform the client and focus the project, and will also provide a strong base on which to develop an appropriate and useful solution. It is also important to consider the role the audience themselves play in the construction of meaning within the context of visual communication.

Some designers have attempted to break with the traditions of the transmitter-receiver model of visual communication. Although the notion of the passive receiver of a message has been questioned within communication and language studies for many years now, it remains a fundamental principle within graphic design, both in the profession and within the academy. Through the creation of more fluid and 'open' visual messages, the designer can attempt to engage the reader in a dialogue, to empower the receiver in the construction of meaning from within a message. By breaking the hierarchy implicit in the transmission of messages, this model could also help to critique the values underpinning the message itself as well as the medium through which it is transmitted, graphic design. Experiments in this field include the wide range of responses to the theories of post-structuralism and deconstruction, particularly those conducted at the Cranbrook Academy in the US during the mid 1990s, together with the 'reflexive' work of politically active designers such as Jan van Toorn in the Netherlands.

Experiments which relate directly to communication theory can be a useful tool for graphic designers in charting alternative views of the function and purpose of visual communication – in particular those giving a greater emphasis to the receiver of the message. This way of thinking about design and communication is

Post-structuralism

A body of theory relating to the distinctions between speech and writing. The French philosopher Jacques Derrida in his seminal work *On Grammatology* challenged the idea that speech is more important than writing. Derrida stated that all systems or structures have a centre – a point of origin – and that all systems are constructed from binary pairs that are in relation or opposition to each other.

Deconstruction

The term deconstruction denotes a particular kind of practice in reading, and a mode of analytical critical inquiry. It is a theory of reading which aims to expose and undermine the logic of opposition within texts (both written and visual).

This critical analysis sets out to question the priority of things which are set up as original, natural, or self-evident. Deconstructive readings are often part of a broader form of interpretation based on a firm critical position (for instance feminist, new historicist or Marxist critique). As such, they are often used to destabilise the range of inherent hierarchical oppositions in the text (between male and female, elite and popular culture, economic class, etc.).

useful, as it allows the designer to view the reader as an active, rather than passive, participant in the process. Of course, this is relevant within both academic and commercial arenas: even where a commercial project attempts to target a particular market sector, and appreciation of the audience within that environment is crucial to a successful resolution. Within the allied fields of marketing and advertising, audience analysis and demographic studies are seen as key areas of research in the development of a project. This aspect of the creative process has become increasingly important in those areas of graphic design that attempt to address specific groups of people, such as editorial and information design, and in graphic design targeted audiences in areas of popular culture.

Audience-centred graphic design, then, covers a broad range of activities: from specific communication intended for a tightly defined target or market to attempts at empowering the receiver of the message through the employment of visual devices which display the medium itself and highlight the communication process at work. A substantial body of work relating to audiencing and reception exists within television studies and film theory, but little work has been done in this area with regard to graphic design and an examination of the ways in which readers interpret visual messages in printed form or via interactive displays. Given that graphic design is largely based on very clear and specific intentions with regard to the content and context of a message, this would seem to be an area rich in potential for further study.

Audience

A group of spectators or listeners at a concert or a play, or the people reached by a book, film, radio or television programme for instance. The audience for a graphic design product is usually clearly defined by the client or, following a period of primary research, by the designer in consultation with the client.

The term 'audiencing' refers to the ways in which readers interpret and understand texts. Surveys of audience reading are often based on methods adopted from qualitative social science, such as interviews and ethnographic studies, together with quantitative methods based on statistical analysis.

However, one further model for graphic designers to consider is the reflective critical interpretation of images, which can often include a personal deconstruction of existing work or a critical reflection on work being undertaken by the designer himself. Through this analysis of design methods, the designer can become more expert in the range of forms and approaches suitable for a particular context or audience.

A New Kind of Dialogue

Design is not an abstract
theoretical discipline –
it produces tangible artifacts,
expresses social priorities and
carries cultural values.
Exactly whose priorities and
values is at the core of the debate.

Andrew Howard A New Kind of Dialogue – Adbusters: Design Anarchy issue

Case Study 05: The Graphic Score

Brazilian graphic designer Paola Faoro is also a musician and spends her spare time singing in a female acapella group specialising in traditional Brazilian music. It was the combination of these two passions that influenced the project featured here.

Faoro was interested in developing a system to score and annotate wholly vocal musical compositions, by employing devices more effective than traditional musical notes. As the notation was to refer to a vocal score only, without additional instrumentation, Faoro felt that there was an opportunity to develop a system which combined both the musical stave together with the key phrasing and wording within the vocal performance. Her intention was to produce an alternative form of music notation that could be 'read' by musicians (in this case her fellow singers) and by

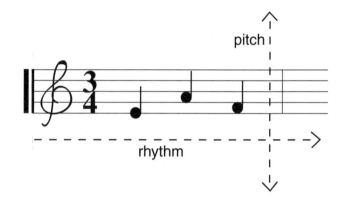

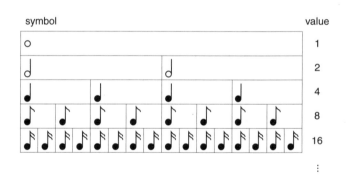

Featured details from Paola Faoro's sketchbooks (opposite and on the following pages) demonstrating her developmental research exploring the existing structure of musical notation, and new forms of notation which could be applied to acapella scores.

The initial investigation for this project involved Faoro in the survey and analysis of the many different attempts to score music that have been

undertaken by avant-garde musicians and artists such as John Cage and Karlheinz Stockhausen, as well as the more familiar and traditional forms of musical notation (above).

The illustrations on the page opposite demonstrate the range of experiments undertaken by Faoro in her attempts to find an alternative form for the scoring of musical compositions. Significantly, the

project does not attempt to interpret the music in a personal or subjective way, but attempts to find an objective way to notate the sounds, pitch, duration and harmonies of the female acapella composition. Faoro's background as both a musician and member of a singing group, as well as her training as an architect before studying typographic design, were important factors in her approach to the project.

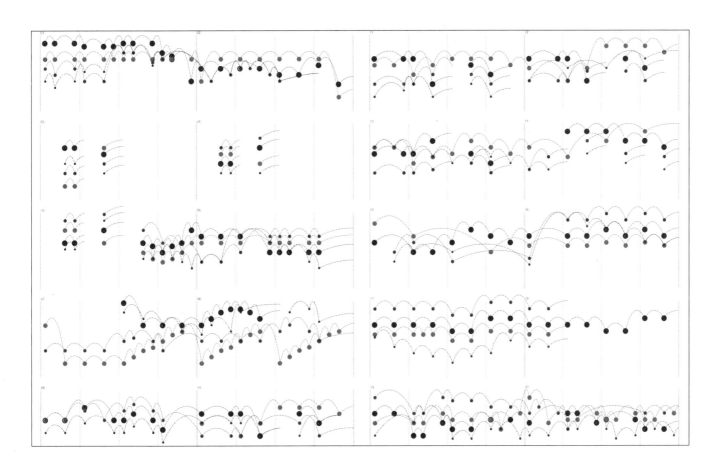

the audience alike. Faoro's investigations led her to explore the transcription of existing musical notation and song lyrics into purely typographic structures that captured the detailed instructions to performers concerning pitch, duration and pacing. These typographic scores could then be used both as notation for the performer to follow and as a guide to the audience for the performance itself.

When following the typographic score whilst listening to the performance, the complex system by which the three vocal performances combine together in harmony can be made more explicit to the listener. Often, elaborate words and phrases are constructed by the combination of two or more voices, and Faoro's notation systems can help to clarify these points of convergence and divergence in an elegant graphic form. This exploration led to further experiments that

utilised colour and shape to construct the score in order to make the musical relationship between the singing voices themselves more explicit, rather than giving emphasis to the lyrical structure. In this way, the harmonic structure and nodal points – where key phrases are emphasised through the combination of voices – can be highlighted. As a form of pure research, this project generated a diverse range of experimental notation systems, which could be used to emphasise and enhance a number of key elements in the performance of acapella music.

Faoro's efforts to find an alternative way to represent musical notation were also influenced by her interest in developing a system that could be 'read' by musicians and singers in a similar, but more direct, manner than traditional forms of musical scoring. The intended audience for this work is a specialist one, already well-versed in an understanding of music and its structure. Like any system of notation, such as Pitman shorthand for example,

there is a requirement to 'learn' the system before using it.

Faoro pursued a number of different approaches in her project – exploring the possibilities of words and typography, colour, shape and line and combinations of these elements in her initial investigations. Faoro's methodology was to break down elements of the musical score by examining singular aspects such as duration,

accent or pitch. Faoro was then able to develop a system of comparative analysis which allowed her to compare individual tests, and then combine the more successful outcomes in order to create a more sophisticated visual notation system which draws on the range of successful experiments in each area.

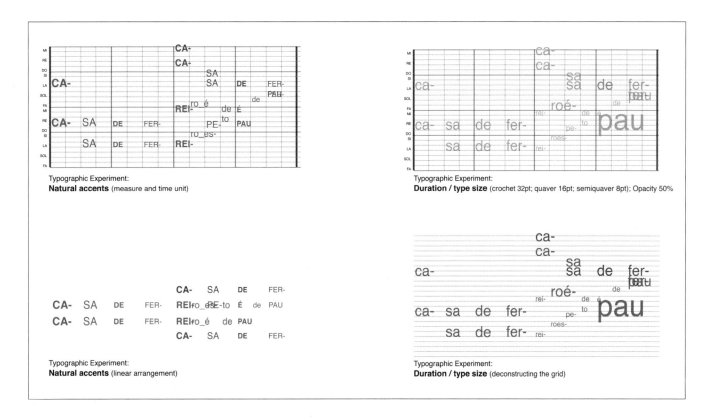

Typographic Experiment:
Natural accents (measure and time unit)

Typographic Experiment:
Duration / type size (crochet 32pt; quaver 16pt; semiquaver 8pt); Opacity 50%

Typographic Experiment:
Natural accents (linear arrangement)

Typographic Experiment:
Duration / type size (deconstructing the grid)

Case Study 06: Fonik – A Phonetic System

Information designer Anna Plucinska created the font entitled 'Fonik' (pictured on the following pages) in an attempt to explore and develop a new phonetic writing system for use in a number of different languages.

The font employs a scientific foundation as its starting point and is based upon the shared physiognomy of human anatomy – in particular the organs which create sound and speech. As part of her initial research Plucinska also investigated the relationship between speech sound and writing systems.

Although this project was a self-initiated one and as such did not have an immediate client or commission, Plucinska's approach was to locate the project in a practical context. The International Phonetic Alphabet (IPA) is commonly used today by linguists, speech therapists and lexicographers to provide guidance and to indicate how words should be pronounced in a large number of languages. The Fonik font attempts to develop the IPA by adding a further level of information to individual glyphs in the font, graphically indicating the physical formation of each sound. Plucinska investigated how the sound of language is formed by a number of physical factors such as the lungs, vocal chords, tongue, teeth, lips and the nasal cavity. These elements work together to create a vast range of subtleties and differences in the pronunciation of the sounds of spoken languages.

In the study of phonetics speech sounds are classified according to the place and manner of their articulation (such as the lips, teeth etc.) and also, more broadly, as vowels and consonants. The spoken English language for example requires 34 different sounds. These are subdivided into 12 vowel sounds and 22 consonant

This experiment (opposite) builds upon Anna Plucinska's earlier investigations into the use of pie charts and graphs as a device for representing each phonetic sound. Plucinska used the basic structure of the circle and a series of concentric rings (rather than the traditional segments of a pie chart) and employed shaded tonal sections as the basic structure for each sound. Whilst this diagrammatic system produced a series of related and logical individual characters, Plucinska found it difficult to arrange the material in a coherent linear fashion to form an efficient and practical writing system.

It should be noted that the intended audience for the final font is a specialist one – comprised of individuals who are, to a greater or lesser degree, already conversant with the existing International Phonetic Alphabet. As such some aspects of readability, or the degree that the font might be more widely understood by a broader audience, are relegated in their significance.

In this series of experiments in the construction of the Fonik font Plucinska represents the phonetic sounds as three-dimensional shapes using a central axis point for three 'branches' that represent the three physical elements determining the sound.

This system works in a similar way to the circular patterns on the previous page, but these new shapes more closely resemble letterforms and can be more easily combined within a linear writing structure.

Consonants
Sounds produced by partially or totally obscuring the vocal tract that are normally used at the periphery of the syllable.

Vowels
Sounds that are produced with little or no obstruction in the vocal tract.

Writing
The system of symbolic representation of language in graphic form.

Syllable
A unit of linguistic structure and pronunciation usually uttered without interruption as a word or part of a word.

Grammar
The system of rules and categorisation that allows us to form and interpret the individual words and sentences that make up our language. Defined as both an art and a science of the inflexions in language or other means of showing the relationship between words used in speech or writing and their phonetic system.

sounds. Plucinska's approach was to develop a series of diagrams that allowed her to make a comparative analysis between ranges of graphically differentiated forms, the methods of sound generation in spoken language production as outlined above.

Plucinska describes the final version of these experiments as 'letter look-alikes'. The proximity to existing letterforms is intended to help the reader recognise basic letter shapes that represent a new value, emphasis or meaning. The experiments followed a systematic progression, each new design building upon the previous one – ranging in scope from rectilinear and curved shapes, the use of colour and direction to the more familiar letter shapes and symbols based on typographic grid structures. Within this process of investigation the <Context-Experimentation> methodology (page 60) is used to

good effect by Plucinska who utilised a broad range of criteria to construct a project based on her interest in both language systems and information design (the field of study) in order to develop a highly personal but focused project that has a number of possibilities for later application.

The rigour of her approach is manifest in the number of related and sequential visual tests – all of which have been informed by a consistent set of criteria and which have served to inform the project in general. Plucinska completed the initial font design by testing her ideas in a series of interviews with linguists and teachers (who regularly use the IPA). This feedback can be used as a basis for the next stage of her project development.

Some of the consonant and vowel symbols that make up the final iteration of Plucinska's Fonik alphabet system (opposite).

In some cases the 'letter look-alikes' are recognisable or familiar, and in other instances are new versions based upon the traditional letterforms of the western alphabet. This final version of the font is designed to be read in a traditional linear form and was tested on a range of subjects from schoolchildren to linguistic experts. The feedback and guidance gained from this process will inform the next stage in the development of the project as it moves closer to a usable, practical font which can be applied as both a text and a display typeface.

Key Concepts

Post-structuralism, in particular deconstruction, takes its starting point from the earlier ideas of structuralism proposed by Saussure and Peirce and is significant as a theory or framework for considering the exploration of the opposition between speech and writing. The French philosopher Jacques Derrida challenges the idea that speech is regarded as more important than writing in his seminal work *On Grammatology*. Derrida states that all systems or structures have a centre – a point of origin – and that all systems are constructed from binary pairs that are in relation or opposition to each other.

The focus on speech versus writing is an example of this: SPEECH = PRESENCE and WRITING = ABSENCE. Speech, which is associated with presence, is traditionally favoured over writing and absence – Derrida terms this **logocentrism**. Derrida is concerned with the idea that these oppositions (also referred to as antonyms) exist to define each other: GOOD-EVIL, for example, and that rather than operating separately they work together and are part of each other. Post-structuralist ideas deny the distinction between the signifier and signified – signifiers are words that refer to other words and their meaning is determined by one word's difference from another. The meaning of an object (the signified) is not present in this sign itself but in its relation to other signs. Derrida terms this **differance**.

The concepts of **denotation** and **connotation** are useful in this context – every word or phrase has potentially two kinds of meaning. **Primary**, literal meaning – **denotation** – and **secondary** meaning – **connotation**. This can be applied to all visual signs. A magazine advertisement, for example, depicting an attractive, well-dressed couple in an expensive looking car may be a promotion for the clothes or jewellery they are wearing. The connotated meaning may suggest that purchasing one of these items is the key to achieving a happy life and a successful career, to own an expensive car and to have a relationship with an attractive partner. The context of this advertisement in a consumer or lifestyle magazine and our experiences and cultural background will have an impact on how we 'read' the image used and our relationship to its coded messages. The meaning of the representation and how we 'read' it is not fixed by its creator or author but is equally determined by the reader.

→**ALL**

Post-structuralism

EXPERIENCE

Deconstruction

DEPENDS ON

Derrida

LANGUAGE←

PROCESS
AND MATERIALS

MAKING MEANING

EXPERIMENTATION WITHIN THE DESIGN STUDIO: SYSTEMATIC APPROACHES TO THE PRODUCTION OF PRACTICAL WORK

Process and Materials

This chapter deals with the notion of systematic approaches and experimentation within the design studio through the production of practical work. Materials investigation is explored, within the professional arena, through the testing of appropriate form relative to a consistently applied set of criteria, and as a process in itself in the exploration of new and innovative visual languages appropriate to specific audiences or circumstances.

Many creative disciplines within the visual arts arena place a great deal of emphasis on surface and materials – that which is termed the 'plasticity' of the image. In the field of fine arts, such as painting and sculpture, for instance, the base materials (oil paints, acrylics, watercolours, pastels, bronze, stone etc.) used in the construction of the work are crucial to the reading and understanding of that work. Similarly, photographs carry meaning through their material nature and also the context within which they are displayed: on a wall in a gallery or home, in a family album, within an archive.

One key difference with the disciplines of film and photography, however, lies within the nature of the image itself. The 'realism' of the photographic image, particularly through the use of colour film, can lead the viewer to read the content of the image – the scene depicted – but ignore its materiality (the photographic paper, borders, mounts and frames etc). As Elizabeth Edwards and Janice Hart indicate in their book, *Photographs Objects Histories*, '*The prevailing tendency is that photographs are apprehended in one visual act, absorbing image and object together, yet privileging the former. Photographs thus become*

Materiality

This relates to the physical properties of an object. In graphic design this might mean the physical nature of a book for example – how it is printed, its binding, the materials it is constructed from and its status as an object beyond its content and functionality as a form of communication. An approach to design which focussed on materiality would encompass the relationship of the physical properties of the book to its intended audience and the relevance of how it is presented as a whole.

This aspect of design is sometimes referred to as the plastic or 'plastique' of an object, in relation to the combination of a number of elements into a whole. With reference to the visual arts in general, the term is derived from the phrase 'plastic arts' in particular referring to three-dimensional art such as sculpture. In the context of graphic design, materiality or plasticity can also refer to an activity where there is no physical object present – including screen based, interactive and virtual environments such as the internet or cyberspace.

detached from their physical properties and consequently from the functional context of a materiality that is glossed merely as a neutral support for images.' Where the material nature of the photograph does take primacy, it is usually within the field of the 'fine print' or in regard to conservation.

Graphic design, particularly in the printed form, lies somewhere between artistic craft or mark-making and photographic realism. It lacks the supposed neutrality or transparency of the photographic image, but still usually foregrounds the 'internal' message – the content – rather than the surface material as the central conveyor of meaning. At the same time, the surface is usually clearly evident, as printed material or bound book for instance. This materiality is often emphasised by the use of typographic elements and graphic symbols which are read as a series of visual codes rather than a pictorial image. Graphic design is, therefore, a product with a complex range of signifiers – the visual lexicon of design.

Meaning is communicated through the plasticity of materials, the physical nature of the object (such as the weight and size of a book), the printed surface and inclusion of (often) photographic images, and the visual codes and languages of typographic composition, colour, harmony, balance and tone.

The tactile nature of designed objects which are intended to be held in the hand (books, magazines, packaging, postcards) carries meaning in a similar way to the surface and brushwork of a painting, or the ergonomic nature of a piece of product design. At the same time, the denotative meaning of a piece of visual communication is usually contained within the visual

Research

A critical investigation or a search or enquiry to discover new facts and information or to collect and collate old data. This would encompass the study of a subject, employing the analysis of quantitative and/or qualitative data. Research employs methods and schemes of testing to interpret events, facts or information, and is a process of observation, discovery and recording.

In the context of graphic design, research provides the foundations of the design process of problem solving and visual communication. The research component of a graphic design brief can take a singular form in some projects such as the collation of audience feedback to a proposal or it can operate in a number of forms simultaneously, each body of research findings working together and in tandem to inform the overall approach to a project. In recent years graphic design has grown to accommodate a wide variety of approaches and intentions.

Significantly, for a number of designers research is a central and defining activity in their work. In these cases research is more than an activity used to define effective visual solutions to a client's brief or problem. It instead becomes an outcome in its own right, informing a designer's or design group's approach, and generates a way of developing new ideas and techniques of thinking and making.

The Design of the Method

The design of the research method and the design of the design method are tasks of a higher order than the design of the communications.

Jorge Frascara User-Centred Graphic Design

forms arranged on its surface: a poster, for instance, which is designed to be viewed from a distance, relies more heavily on the visual composition of graphic elements than on the material upon which it is printed to convey its message.

It should also be noted that the ephemeral nature of much graphic design output does go some way to explain the nature of designed artefacts as material objects. Necessity, budget and the speed of production can play a major role in limiting the range of materials selected to complete a project. The choice of paper for printing flyers or posters, for instance, is often driven by cost considerations rather than the tactility or durability of the material.

Developing technologies also play a major role in the material nature of graphic design artefacts. As print and screen technologies develop, so new working methods and aesthetic possibilities are opened up for the designer. The history of graphic design as a subject is inherently intertwined with that of developing print, mechanical, and more recently, electronic reproduction processes, from letterpress, lithographic and digital printing to the evolution of the world wide web and interactive digital technologies.

Each new technology has seen a shift in contemporary graphic design aesthetics, and design historians have made detailed studies of the impact of each change in both working methods and materials. The development of photolithography between the 1920s and 1950s, for instance, prefigured a widespread shift to the inclusion of photographs – rather than woodcuts, etchings and hand drawn illustrations – within a range of inexpensive printed matter such as posters and

Methodology
The science of method, or a body of methods, employed in a particular activity such as the research aspects of a project. A logical, pre-defined, and systematic strategy by which to undertake a graphic design project, to include methods of evaluation of experimental outcomes, a schedule for each stage of the project and a stated intention or purpose in relation to anticipated outcomes. It could also be employed to describe an approach to graphic design in general: a particular manner of working or a procedure used in the production of graphic design. Sometimes used in reference to organisation or a technique of organising and analysing, or a scheme of classification.

'...the essential idea in this tradition in the Western university is that it is possible to critique action so as to produce more enlightened or more effective forms of action. The critical thinking in this tradition is a practice in the world, a praxis. The basis of any new knowledge or further understanding is explored through research; knowledge situated in practice is not, as is sometimes implied, a newish form of knowing alongside propositional knowledge, but is a tradition of enduring character.' **Ronald Barnett**, *Higher Education: A Critical Business* (Open University Press 1997)

magazines. Similarly, the late 1980s and 1990s saw the development of a range of previously inconceivable design methods which could be achieved only through the use of computer technology.

The signifying nature of materials is important within certain areas of the graphic designer's craft, particularly in the communication of 'quality' or 'tactility' in book design or packaging, for instance. The graphic designer should therefore pay close attention to the materials with which to reproduce their work, particularly where the resulting object is designed to be touched or held in the hand. The process of materials experimentation runs in parallel to the processes discussed in Chapter 3: Visual Research – but whereas the visual research methodology is primarily concerned with the composition of visual elements, materials research follows similar investigations with the tactile form of the designed object. These two areas go hand in hand, of course – the materials always affect the surface aesthetic as well as adding to the complex chain of signifiers and visual grammar of the object, through which the reader or viewer derives meaning. Through a range of tests related to the visual and tactile form of the graphic outcome of a project, the designer can help to focus the intended message more clearly in the eyes, and hands, of the viewer.

Affordance

This concept was first introduced by the perception theorist J.J. Gibson. Affordances are the range of possibilities that an object or environment offers (or appears to offer) in order to perform an action upon it.

The classical example is that of the door, whereby the presence of a flat metal plate would indicate that the user needs to push, whereas a grab handle would indicate the need to pull the door open.

Donald A. Norman, in his book *The Design of Everyday Things*, explains how the reinforced glass panels erected by British Rail and used as shelters for railway passengers were shattered by vandals as soon as they were replaced. The situation changed when they decided to substitute the glass panels for plywood boarding. Although the force needed to break the plywood was equivalent to that of the glass, the shattering stopped. Instead of smashing them, the vandals carved the wood or wrote on its surface. Glass allows us to see through it and can be shattered into a thousand pieces. In this 'psychology of materials' the affordances of wood make it rather more appealing to write on or carve than to smash.

(Opposite) A typographic notation system relating to the study of narrative and temporality in the novel *Dracula*. This project, by Sarah Backhouse is explored in detail over the following pages (Case Study 07).

2

Lucy & Mina were
tired, and went to bed.

Mina wrote diary in
shorthand.

Lucy fell asleep.

Mina went to bed &
slept straight away.

11 August/am:
Lucy felt awake but
supposed she must
have been asleep.

She was afraid of
'something'

She wanted to be
near the Abbey, in the
churhyard.

She remembered
passing through the
streets.

Lucy heard lots of dogs
howling when she
crossed the bridge &
walked up the steps.

Mina woke up &
found that Lucy was
not in bed.

She checked the
sitting-room.

She checked the rest
of the house.

She noticed hall-door
was open slightly.

inn, with a bow-window right over the seaweed-covered rocks of the strand. I believe we should have shocked the 'New Woman' with our appetites. Men are more tolerant, bless them! Then we walked home with some, or rather many, stoppages to rest, and with our hearts full of constant dread of wild bulls. Lucy was really tired, and we intended to creep off to bed as soon as we could. The young curate came in, however, and Mrs Westenra asked him to stay for supper. Lucy and I had both a fight for it with the dusty miller; I know it was a hard fight on my part, and I am quite heroic. I think that some day the bishops must get together and see about breeding up a new class of curates, who don't take supper, no matter how they may be pressed to, and who will know when girls are tired. Lucy is asleep and breathing softly. She has more colour in her cheeks than usual, and looks, oh, so sweet. If Mr Holmwood fell in love with her seeing her only in the drawing room, I wonder what he would say if he saw her now. Some of the 'New Women' writers will some day start an idea that men and women should be allowed to see each other asleep before proposing or accepting. But I suppose the 'New Woman' won't condescend in future to accept; she will do the proposing herself. And a nice job she will make of it, too! There's some consolation in that. I am so happy tonight, because dear Lucy seems better. I really believe she has turned the corner, and that we are over her troubles with dreaming. I should be quite happy if I only knew if Jonathan ... God bless and keep him.

11 AUGUST 3 AM
Diary again. No sleep now, so I may as well write. I am too agitated to sleep. We have had such an adventure,

3

Lucy Westenra's memory

'... it all seemed to be real. I
only wanted to be here in this
spot – I don't know why, for
I was afraid of something – I
don't know what. I remember,
though I suppose I was asleep,
passing through the streets and
over the bridge. A fish leaped as
I went by, and I leaned over to
look at it, and I heard a lot of
dogs howling – the whole town
seemed as if it must be full of
dogs all howling at once – as I
went up the steps. Then I have
a vague memory of something
long and dark with red eyes, just
as we saw in the sunset, and
something very sweet and very
bitter all around me at once; and
then I seemed sinking into deep

such an agonizing experience. I fell asleep as soon as I had closed my diary ...

Suddenly I became broad awake, and sat up, with a horrible sense of fear upon me, and of some feeling of emptiness around me. The room was dark, so I could not see Lucy's bed; I stole across and felt for her. The bed was empty. I lit a match, and found that she was not in the room. The door was shut, but not locked, as I had left it. I feared to wake her mother,† who has been more than usually ill lately, so I threw on some clothes and got ready to look for her. As I was leaving the room it struck me that the clothes she wore might give me some clue to her dreaming intention. Dressing-gown would mean house; dress, outside. Dressing-gown and dress were both in their places. 'Thank God,' I said to myself, 'she cannot be far, as she is only in her nightdress.' I ran downstairs and looked in all the other rooms of the house, with an ever-growing fear chilling my heart. Finally I came to the hall-door and found it open. It was not wide open, but the catch of the lock had not caught. The people of the house are careful to lock the door every night, so I feared that Lucy must have gone out as she was. There was no time to think of what might happen; a vague, overmastering fear obscured all details. I took a big, heavy shawl and ran out. The clock was striking one as I was in the Crescent, and there was not a soul in sight. I ran along the North Terrace, but I could see no sign of the white figure which I expected. At the edge of the West Cliff above the pier I looked across the harbour to the East Cliff, in the hope or fear – I don't know which – of seeing Lucy in our favourite seat. There was a bright full moon, with heavy black, driving clouds, which threw the whole

green water, and there was a singing in my ears, as I have heard there is to drowning men;
and then everything seemed passing away from me; my soul seemed to go out from my body
and float about the air. I seem to remember that once the West Lighthouse was right under
me, and then there was a sort of agonising feeling, as if I were in an earthquake, and I came
back and found you shaking my body. I saw you do it before I felt you.'

Case Study 07: Temporality in Stoker's Dracula

This project, by book designer Sarah Backhouse, is an attempt to develop a typographic system for charting the passage of time within the 19th century Gothic novel *Dracula* by Bram Stoker. The novel comprises of a series of fictional diary entries, letters and documents 'written' by the range of characters central to the story. Many of these texts relate to one another through their description of events and locations from each fictional participant's viewpoint, and the overall narrative is held together through a complex series of interrelated structures.

Backhouse chose to analyse the text in a number of ways, such as through the mapping of timelines, locations, characters and events. She also looked in detail at the history of the genre of Gothic novels, and in particular at the development of Bram Stoker's

Dracula from its first edition in 1897 through to a range of redesigns and new editions during the 20th century. A detailed study of narratology and the function of distinct elements in the text led the designer to focus primarily on the passage of time throughout the book. The sequence of events occurring during the day and at night are, of course, central to the narrative in the case of the vampire story. Backhouse began by developing a system to denote the time of day described in each section of the text, taking cues from specific times and dates mentioned in letters and diaries. More general moments – such as the description of a lunch or dinner for instance – could be mapped in relation to the more accurate times already noted.

Backhouse was keen to create a system which could run alongside the original story, leaving the body of

Book designer Sarah Backhouse conducted the project (opposite) as a study into temporality in Bram Stoker's *Dracula*. This personal project combines a wide range of secondary research topics, from literary theory to narratology and typographic design.

Early experiments (bottom left) attempted to relate the passing of time to the narrative text through the inclusion of

photographs of both the night and daytime skies, taken across a period of 24 hours. Each specific time of day within the text could then be linked with a photograph denoting the information.

A range of experiments in the formal setting of official letters which occur within the text at regular points (bottom right) allowed the designer to make subtle breaks between the personal diary entries of the

main characters and the more formal setting of the official typewritten texts from solicitors and journalists.

Further experiments (above right) refined the use of the sky images into a continuous band along the top edge of the page, and attempted to bring coinciding elements of text together on the same page through the use of extensive footnotes and references.

3 am Mina wrote her diary. At dawn Mina went to bed. In the morning Mina woke up Lucy. Mina thought she had hurt Lucy's throat. Lucy was indifferent to this injury.

Noon Mina wrote her diary. Mrs. Westenra & the Lucy & Mina had lunch in Mulgrave Woods.

Evening Mina & Lucy walked to the Casino Terrace for a concert.

Lucy & Mina went to bed early. Lucy fell asleep straight away. Mina wrote her diary, locked the door & tied the key to her wrist.

say a word to any one, even her mother, about her sleep-walking adventure. I hesitated at first to promise; but on thinking of the state of her mother's health, and how the knowledge of such a story might become distorted–nay, infallibly would–in case it should leak out, I thought it wise to do so. I hope I did right. I have locked the door, and the key is tied to my wrist, so perhaps I shall not be again disturbed. Lucy is sleeping soundly; the reflex of the dawn is high and far over the sea …

SAME DAY NOON
All goes well. Lucy slept till I woke her, and seemed not to have even changed her side. The adventure of the night does not seemed to have harmed her; on the contrary, it has benefited her, for she looks better this morning than she has done for weeks. I was sorry to notice that my clumsiness with the safety-pin hurt her. Indeed, it might have been serious, for the skin of her throat was pierced.† I must have pinched up a piece of loose skin and have transfixed it, for there are two little red points like pin pricks, and on the band of her nightdress was a drop of blood. When I apologised and was concerned about it, she laughed and petted me, and said she did not even feel it. Fortunately it cannot leave a scar, as it is so tiny.

SAME DAY NIGHT
We passed a happy day. The air was clear, and the sun bright, and there was a cool breeze. We took our lunch to Mulgrave Woods, Mrs Westenra driving by the road and Lucy and I walking by the cliff path and joining her at the gate. I felt a little sad myself, for I could not but feel how absolutely happy it would have been had Jonathan been with me. But there! I must only be patient. In the evening we strolled in the Casino Terrace, and heard some good music by Spohr and Mackenzie, and went to bed early. Lucy seems more restful than she has been for some time, and fell asleep at once. I shall lock the door and secure the key the same as before, though I do not expect any trouble tonight.

From: Sister Agatha, Hospital of St Joseph and Ste Mary, Buda-Pesth. To: Miss Wilhelmina Murray, Exeter.
12 August

Dear Madam,
I write by desire of Mr Jonathan Harker, who is himself not strong enough to write, though progressing well, thanks to God ad St Joseph and Ste Mary. He has been under our care for nearly six

6

12 August Mina woken up twice by Lucy sleepwalking. Mina and Lucy both woke up with the dawn.

13 August Mina woken by Lucy, who was pointing at the window.

Mina went to the window, saw a huge bat, which was frightened away by her.

14 August Mina wrote diary for 13 August. Mina & Lucy spent the day on the East Cliff, read and wrote.

lunch/ tea /dinner: Mina found that Lucy was reluctant to leave the spot for meal times.

sunset : at West Pier they watched the sun set.

12 AUGUST
My expectations were wrong, for twice during the night I was wakened by Lucy trying to get out. She seemed, even in her sleep, to be a little impatient at finding the door shut, and went back to bed under a sort of protest. I woke with the dawn, and heard the birds chirping outside of the window. Lucy woke, too, and, I was glad to see, was even better than on the previous morning. All her old gaiety of manner seemed to have come back, and she came and snuggled in beside me, and told me all about Arthur; I told her how anxious I was about Jonathan, and then she tried to comfort me. Well, she succeeded somewhat, for, though sympathy can't alter the facts, it can help to make them more bearable.

13 AUGUST.
Another quiet day, and to bed with the key on my wrist as before. Again I awoke in the night, and found Lucy sitting up in bed, pointing to the window. I got up quietly, and pulling aside the blind, looked out. It was brilliant moonlight, and the soft effect of the light over the sea and sky–merged together in one great, silent mystery–was beautiful beyond words. Between me and the moonlight flitted a great bat, coming and going in great, whirling circles. Once or twice it came quite close, but was, I suppose frightened at seeing me,‡ and flitted away across the harbour towards the Abbey. When I came back from the window Lucy had lain down again, and was sleeping peacefully. She did not stir again all night.

14 AUGUST.
On the East Cliff, reading and writing all day. Lucy seemed to have become as much in love with the spot as I am, and it is hard to get her away from it when it is time to come home for lunch or tea or dinner. This afternoon she made a funny remark. We were coming home for dinner, and had come to the top of the steps up from the West Pier and stopped to look at the view as we generally do. The setting sun, low down in the sky, was just dropping behind Kettleness; the red light was thrown over on the East Cliff and the old Abbey, and seemed to bathe everything in a beautiful rosy glow.

weeks, suffering from a violent brain fever. He wishes me to convey his love, and to say that by this post I write for him to Peter Hawkins, Exeter, to say, with his dutiful respects, that he is sorry for his delay, and that all his work is completed. He will require some few weeks' rest in our sanatorium in the hills, but will then return. He wishes me to say that the has not sufficient money with him, and that he would like to pay for his staying here, so that others who need shall not be wanting for help. Believe me,
Yours, with sympathy and all blessings,
Sister Agatha.
P.S.–My patient being asleep, I open this to let you know something more. He has told me all about you, and that you are shortly to be his wife. All blessings to you both! He has had some fearful shock–so says our doctor–and in his delirium his ravings have been dreadful; of wolves and poison and blood; of ghosts and demons; and I fear to say of what. Be careful with him always that there may be nothing to excite him of this kind for a long time to come; the traces of such an illness as his do not lightly die away. We should have

7

was pierced. I must have pinched up a piece of loose skin and have transfixed it, for there are two little red points like pin-pricks, and on the band of her nightdress was a drop of blood. When I apologised and was concerned about it, she laughed and petted me, and said she did not even feel it. Fortunately it cannot leave a scar, as it is so tiny.

SAME DAY, NIGHT. —

We passed a happy day. The air was clear, and the sun bright, and there was a cool breeze. We took our lunch to Mulgrave Woods, Mrs Westenra driving by the road and Lucy and I walking by the cliff path and joining her at the gate. I felt a little sad myself, for I could not but feel how absolutely happy it would have been had Jonathan been with me. But there! I must only be patient. In the evening we strolled in the Casino Terrace, and heard some good music by Spohr and Mackenzie, and went to bed early. Lucy seems more restful than she has been for some time, and fell asleep at once. I shall lock the door and secure the key the same as before, though I do not expect any trouble tonight.

12 AUGUST. —

My expectations were wrong, for twice during the night I was wakened by Lucy trying to get out. She seemed, even in her sleep, to be a little impatient at finding the door shut, and went back to bed under a sort of protest. I woke with the dawn, and heard the birds chirping outside of the window. Lucy woke, too, and, I was glad to see, was even better than on the previous morning. All her old gaiety of manner seemed to have come back, and she came and snuggled in beside me, and told me all about Arthur; I told her how anxious I was about Jonathan, and then she tried to comfort me. Well, she succeeded somewhat, for, though sympathy can't alter facts, it can help to make them more bearable.

1 · 2 · 3 · 4 · 5 · 6 · 7 · 8 · 9 · 10 • **11** • **12** • 13 • 14 · 15 · 16 · 17 · 18 · 19 · 20 · 21 · 22 · 23 · 24 · 25 · 26 · 27 · 28 · 29 · 30 · 31

13 AUGUST. —

Another quiet day, and to bed with the key on my wrist as before. Again I awoke in the night, and found Lucy sitting up in bed, still asleep, pointing to the window. I got up quietly, and pulling aside the blind, looked out. It was brilliant moonlight, and the soft effect of the light over the sea and sky — merged together in one great, silent mystery — was beautiful beyond words. Between me and the moonlight flitted a great bat, coming and going in great, whirling circles. Once or twice it came quite close, but was, I suppose frightened at seeing me, and flitted away across the harbour towards the Abbey. When I came back from the window Lucy had lain down again, and was sleeping peacefully. She did not stir again all night.

14 AUGUST. —

On the East Cliff, reading and writing all day. Lucy seems to have become as much in love with the spot as I am, and it is hard to get her away from it when it is time to come home for lunch or tea or dinner. This afternoon she made a funny remark. We were coming home for dinner, and had come to the top of the steps up from the West Pier and stopped to look at the view as we generally do. The setting sun, low down in the sky, was just dropping behind Kettleness; the red light was thrown over on the East Cliff and the old Abbey, and seemed to bathe everything in a beautiful rosy glow. We were silent for a while, and suddenly Lucy murmured as if to herself: —

'His red eyes again! They are just the same.' It was such an odd expression, coming apropos of nothing, that it quite startled me. I slewed round a little, so as to see Lucy well without seeming to stare at her, and saw that she was in a half-dreamy state, with an odd look on face that I could not quite make out; so I said nothing, but followed her eyes. She appeared to be looking over at our own seat, whereon was a dark figure seated alone. I was a little startled myself, for it seemed for an instant as if the stranger had eyes like burning flames; but a second look dispelled the illusion. The red sunlight was

1 · 2 · 3 · 4 · 5 · 6 · 7 · 8 · 9 · 10 · 11 · 12 • **13** • **14** • 15 · 16 · 17 · 18 · 19 · 20 · 21 · 22 · 23 · 24 · 25 · 26 · 27 · 28 · 29 · 30 · 31

A range of book formats and sizes, typographic grids and paper stocks were tested in order to discover a useable working model for the book. Key information contained within the text could then be enhanced though subtle visual treatments in the design.

The incorporation of more subtle typographic marks to denote date and time along the bottom of the page (above), together with the use of the sky photograph visual bands transposed to a vertical setting, allow the visual information to relate more specifically to the body text itself. In this way, as the narrative unfolds in the text, the colour bands can be compressed or extended to parallel the passing of time in the story.

A more detailed analysis of the text revealed a range of specific references to time within the story, which could be highlighted through the use of a typographic grid and timeline (above right).

Dr Seward's diary

19 August.-

Strange and sudden change in Renfield last night. About eight o'clock he began to get excited and to sniff about as a dog does when setting. The attendant was struck by his manner and knowing my interest in him, encouraged him to talk. He is usually respectful to the attendant, and at times servile; but tonight, the man tells me, he was quite haughty. Would not condescend to talk with him at all. All he would say was:-

'I don't want to talk to you: you don't count now; the Master is at hand.'

The attendant thinks it is some sudden form of religious mania which has seized him. If so, we must look out for squalls, for a strong man with homicidal and religious mania at once might be dangerous. The combination is a dreadful one. At nine o'clock I visited him myself. His attitude to me was the same as to the attendant; in his sublime self-feeling the difference between myself and attendant seemed to him as nothing. It looks like religious mania, and he will soon think that he himself is God. These infinitesimal distinctions between man and man are too paltry for an Omnipotent Being. How these madmen give themselves away! The real God taketh heed lest a sparrow fall; but the God created from human vanity sees no difference between and eagle and a sparrow. Oh, if men only knew!

For half an hour or more Renfield kept getting excited in greater and greater degree. I did not pretend to be watching him, but kept strict observation all the same. All at once that shifty look came into his eyes which we always see when a madman has seized an idea, and with it the shifty movement of the head and back which asylum attendants come to know so well. He

form of religious mania: this sentence fixes the doctor in his world of logic - rational scientific thought and explanation is (at this point) the only things the doctor entertains.

a shifty look: The doctor has categorised Renfield, and matches his categories to the scientific theories & clinical observations of the day.

became quite quiet, and went and sat on the edge of his bed resignedly, and looked into space with lacklustre eyes. I thought I would find out if his apathy were real or only assumed, and tried to lead him to talk of his pets, a theme which had never failed to excite his attention. At first he made no reply, but at length said testily:-

'Bother them all! I don't care a pin about them.'

'What?' I said. 'You don't mean to tell me you don't care about spiders?' (Spiders at present are his hobby, and the notebook is filling up with columns of small figures.) To this he answered enigmatically:-

'The bride-maidens rejoice the eyes that wait the coming of the bride; but when the bride draweth nigh, then the maidens shine not to the eyes that are filled.'

He would not explain himself, but remained obstinately seated on his bed all the time I remained with him. I am weary tonight and low in spirits. I cannot but think of Lucy, and how different things might have been. If I don't sleep at once, chloral,† the modern Morpheus‡ - C₂HCl₃O.H₂O! I must be careful not to let it grow into a habit. No, I shall take none tonight! I have thought of Lucy, and I shall not dishonour her by mixing the two. If need be, tonight shall be sleepless ...

Glad I made the resolution; gladder that I kept to it. I had lain tossing about, and had heard the clock strike only twice, when the night-watchman came to me, sent up from the ward, to say that Renfield had escaped. I threw on my clothes and ran down at once; my patient is too dangerous a person to be roaming about. Those ideas of his might work out dangerously with strangers. The attendant was waiting for me. He said he had seen him not ten minutes before, seemingly asleep in his bed, when he had looked through he observation-trap in the door. His attention was called by the sound of

spiders: Through Renfield Stoker develops a mock Darwinian theory of evolution.

†chloral:

chloral, and ingredient in chloral hydrate, a hypnotic and sedative.

‡Morpheus:

In Greek mythology the god of sleep and dreams.

text itself intact. Although the novel has been reprinted and redesigned many times during the last century, the typographic layout has remained remarkably similar. As a book designer, Backhouse felt that the text itself should not be broken down into a new narrative structure based on a chronology of events.

Early experiments involved reproducing photographs of the sky, which had been taken at hourly intervals throughout a 24-hour period. Backhouse also conducted a range of experiments in composition, with the photographs set alongside the text within separate frames, and as a continuous line of colour ranging from light blue to dark blue-black. Ultimately these led to the production of a book with the tonal values of the day and night sky printed along the edges of the page. However, the drawback of this approach was evident in

the lack of accuracy in describing the ways in which periods of time are sometimes expanded and contracted in the text: a period of two or three hours could be described in detail across two pages, whereas one paragraph might describe a period of one or two days. This led the designer to develop alternative notation systems, based on typographic marks, running alongside the text and denoting periods of 24 hours as a series of gridded lines. A common format and grid structure was chosen for all visual experiments, and a wide range of papers and printing techniques were tested in order to evaluate the contrast between type and ground, and the colour reproduction of the graduated photographic lines.

The final outcome for the project was a set of three books which outline alternative systems for mapping the passing of time within Bram Stoker's *Dracula*, each focusing on one single chapter of the original book.

Each system was found to have a number of specific strengths and limitations in relation to the original project intention. The final development of the typographic information system

(above right) shows the passing of time through hourly marks on a vertical timeline, with keylines highlighting the specific references to time in the text.

Other versions of the system proved useful in charting the parts of the story which occur in daylight and at night. The use of the vertical colour gradation based on the original sky photographs (bottom left), together with the incorporation

of a simple typographic timeline, makes the visual information regarding light and dark more instantly apparent.

A similar model which includes those text references to the same events (bottom right) gives the reader further information about the various characters' voices and descriptions of events from different perspectives.

August

MINA MURRAY'S JOURNAL

18 August.—

I am happy today, and write sitting on the seat in the churchyard. Lucy is ever so much better. Last night she slept well all night, and did not disturb me once. The roses seem coming back already to her cheeks, though she is still sadly pale and wan-looking. If she were in any way anæmic I could understand it, but she is not. She is in gay spirits and full of life and cheerfulness. All the morbid reticence seems to have passed from her, and she has just reminded me, as if I needed any reminding, of *that* night, and that it was here, on this very seat, I found her asleep. As she told me she tapped playfully with the heel of her boot on the stone slab and said:—

'My poor little feet didn't make much noise then! I daresay poor old Mr Swales would have told me that it was because I didn't want to wake up Geordie.' As she was in such a communicative humour, I asked her if she had dreamed at all that night. Before she answered, that sweet, puckered look came into her forehead, which Arthur—I call him Arthur from her habit—says he loves; and, indeed, I don't wonder that he does. Then she went on in a half-dreaming kind of way, as if trying to recall it to herself:—

'I didn't quite dream; but it all seemed to be real. I only wanted to be here in this spot—I don't know why, for I was afraid of something—I don't know what. I remember, though I suppose I was asleep, passing through the streets and over the bridge. A fish leaped as I went by, and I leaned over to look at it, and I heard a lot of dogs howling—the whole town seemed as if it must be full of dogs all howling at once—as I went up the steps. Then I have a vague memory of something long and dark with red eyes, just as we saw in the sunset, and something very sweet and very bitter all around me at once; and then I seemed sinking into deep green water, and there was a singing in my ears, as I have heard there is to drowning men; and then everything seemed passing away from me; my soul seemed to go out from my body and float about the air. I seem to remember that once the West Lighthouse was right under me, and then there was a sort of

agonising feeling, as if I were in an earthquake, and I came back and found you shaking my body. I saw you do it before I felt you.'

Then she began to laugh. It seemed a little uncanny to me, and I listened to her breathlessly. I did not quite like it, and thought it better not to keep her mind on the subject, so we drifted on to other subjects, and Lucy was like her old self again. When we got home the fresh breeze had braced her up, and her pale cheeks were really more rosy. Her mother rejoiced when she saw her, and we all spent a very happy evening together.

19 August.—

Joy, joy, joy! although not all joy. At last, news of Jonathan. The dear fellow has been ill; that is why he did not write. I am not afraid to think it or to say it, now that I know. Mr Hawkins sent me on the letter, and wrote himself, oh, so kindly. I am to leave in the morning and go over to Jonathan, and to help to nurse him if necessary, and to bring him home. Mr Hawkins says it would not be a bad thing if we were to be married out there. I have cried over the good Sister's letter till I can feel it wet against my bosom, where it lies. It is of Jonathan, and must be next to my heart, for he is *in* my heart. My journey is all mapped out, and my luggage ready. I am taking one change of dress; Lucy will bring my trunk to London and keep it till I send for it, for it may be that ... I must write no more; I must keep it to say to Jonathan, my husband. The letter that he has seen as touched must comfort me till we meet.

2art.nr.B220273b

Case Study 08: European Postage Stamp Design

Irish graphic designer Fintan McCarthy designed this series of propositional postage stamps and franking marks in response to the development of the new European constitution and the opening of borders and markets between countries within the European Union. McCarthy's proposed system is based on an in-depth study of postage franking and stamping systems across the individual nations of the EU with a view to the creation of a cross-border system that reflects both local cultures and international unity.

Initial research centred on the collection and comparative analysis of a wide range of examples of national and regional postage and franking systems. The individual stamps and franking marks were analysed for their information content and hierarchy, aesthetic considerations and the range of materials and technologies used. Following this analysis, McCarthy devised a number of proposals based on colours of the individual nations' flags, consisting of sheets of printed stamps based on a series of colour bands and perforated to form triangular colour patterns which could be configured by the customer to create new patterns.

Materials were considered important; the need to retain consistency in terms of colour and durability was matched by the need to prevent forgery, as postage stamps carry a similar economic value to coinage (they are in fact a form of currency). The impact of new technologies for franking, tracking and sorting mail was also taken into account by the designer, and a range of franking methods based on current post office technologies were devised. These methods include printed marks and dots to indicate weight, value,

These images (bottom left) are details from Fintan McCarthy's sketchbooks showing the initial research into his field of study – exploring the possibilities of developing a pan-European postage and franking system.

Early in the project McCarthy identified the complexity of the problem he had chosen to investigate. In many cases each country within the European Union has particular legal and technical mailing systems that are very different from those of other member countries and states. More significantly, each country uses its postage system to celebrate national heroes, events, architecture and rulers.

In a similar fashion to the advantages to be found in the adoption of a single European currency, the solution more often than not resides in an aesthetic that is based upon neutrality or a single identity for all. The cultural 'baggage' and xenophobia of each country has to be sidelined in favour of a unified identity.

This image (top left) represents one of McCarthy's proposals for a single European stamp – in this case a sheet of perforated stamps within one overall design which allows the user to customise their mail in a number of permutations.

postage cost and country of origin of sender, together with details relating to sorting and distribution across the international postal network. Some of these marks are designed to be read by machine, in order to aid the sorting process.

Following these practical exercises, McCarthy developed a more pictorial approach to national identity, creating a series of simple, humorous franking marks denoting certain stereotypes from each country of origin. Whilst building on the information design system developed to solve the initial problem, these alternative proposals take an ironic and playful swipe at notions of international unity, and simultaneously demonstrate the ways in which the franking and coding system might be applied.

In a similar way to Sarah Backhouse's *Dracula* narrative

project (p150), McCarthy's work proposes a transferable methodology for the solution to a wide range of problems – in this case an international system of graphic information and transfer, and in Backhouse's case a notation system which can guide the reader in mapping time within a body of text, whether as fictional narrative or factual information.

Further examples of McCarthy's explorations into a single European stamp system (left and overleaf). Because of the difficulties in addressing the different postage pricing structures in each European country McCarthy devised a solution that allows each EU member state to retain its pricing scale but to also use the overarching single identity stamp. This was achieved in McCarthy's proposal by utilising a single sheet of

perforated stamps with an overall design that can be employed in different combinations – each stamp representing a particular monetary value. To design the single identity stamp, McCarthy chose to use colour rather than image or typography.

A considerable aspect of his early research for the project involved looking at colour and symbolism in relation to cultural representation and

custom. Whilst we might assume that within our own culture a particular colour is representative of a particular concept or object, this is not always true of other cultures – even those within neighbouring countries in Europe.

Further proposals developed by McCarthy as part of his project (above and right). These somewhat light-hearted images are part of an effective idea, based upon the franking of envelopes and packages instead of the use of postage stamps. McCarthy suggests that rather than pursue a singular European identity – a somewhat difficult task for politicians let alone graphic designers – the postage system should celebrate cultural difference and national figures.

In an ironic way McCarthy uses the opportunity to comment upon and to remind us that cultural differences still persist – in his use of cultural and national stereotypes, as seen from the 'outside' such as the heads of the pop band *ABBA* to represent Sweden.

Although this might be considered impractical for a pan-European postage system, McCarthy's proposed franking system is based upon the use of existing technology and is an economically viable idea.

Modernism and Postmodernism

→FORM

FOLLOWS

FUNCTION

CONTENT←

Modernism is a term that describes the range of art, design and architectural movements and subsequent ideas that emerged during the first half of the 20th century, also referred to as the modern movement. In reaction to the craft movement and ideas surrounding decoration and adornment, practitioners developed a new approach which celebrated the possibilities of new technologies and methods of mass production in order to enable a better society for all. Many of the art and design movements connected to modernism, such as De Stijl, constructivism and the Bauhaus, endeavoured to celebrate functionalism and rationality under the maxim that 'form follows function'. The modernist approach to graphic design focused upon the use of white space and sans serif typography that utilised asymmetry. This was driven by an adherence to the grid, based on geometry and the proportion of the page, as a controlling device.

Postmodernism is a movement that grew out of a rejection of the ideas of modernism. Significantly many of the original values of modernism had, by the late 1960s, become regarded by designers as dogmatic and only offering a fixed view or superficial style. Postmodernism celebrated a return to earlier ideas of the value of decoration. Rejecting order or discipline in favour of expression and intuition, many of the key progenitors within the field emanated originally from schools such as Basel in Switzerland and later Cranbrook in the US, and were tutored by central figures such as Wolfgang Weingart and Katherine and Michael McCoy. The postmodern lexicon of historical reference, decoration, wit and the ironic employment of vernacular or non-designed elements, such as hand drawn typography, constitutes a departure from the rationality of earlier approaches. This significant development brought about a reappraisal of the process of visual communication with design. Embracing ideas from architecture and 20th century philosophy and semiotics, practitioners have attempted to advance the discussion of how relevant approaches, related to specific groups or cultures, could be developed, rather than aspiring to a universal language.

LESS IS MORE – LESS IS A BORE

SYNTHESIS

RESEARCH AND PRODUCTION

THE INTERRELATIONSHIP BETWEEN THEORETICAL AND PRACTICAL MODELS: APPLICATIONS AND WORKING STRATEGIES FOR THE GRAPHIC DESIGNER WITHIN THE STUDIO ENVIRONMENT

Rethinking Practice

Theory provides the
basis with which to ask
questions not only
about work, but also
through work. And if
nothing else, what
design lacks in terms
of interesting work these days is
not neccessarily more visual variety,
but rather more
provocative questions
and polemical answers.

Andrew Blauvelt Remaking Theory, Rethinking Practice

Synthesis

The concluding stages of any research project involve the convergence of the more successful and effective results of investigations already undertaken in response to the initial problem or idea. The models and methodologies developed at earlier stages can be assessed and built upon as the project develops and moves towards some form of completion or conclusion.

In their everyday work, designers are continually involved in a process of synthesising a complex series of factors ranging from technical production processes, budgets and deadlines to understanding the meanings of messages and addressing intended audiences. Often the interrelationship of these factors will influence the outcome of a project beyond the designer's original intention. This is not to suggest that this process of synthesis is outside of their control –

indeed, a key skill as a designer resides in their ability to prioritise and respond to the various factors emerging in the course of a project.

Research inevitably requires the application of these same skills, but differs slightly in that many of the factors at work will be under the direct control of the designer. The parameters of a brief are often established early on, usually during the investigation of the project's viability through the field of study and the project focus. As a suitable methodology is developed in response to this initial work, these parameters may expand or contract to encompass other aspects and that may in turn again influence the methodological approach to the project.

The synthetic aspect of the research process not only builds upon the initial stages of the project but also

Informed Engagement

An informed or engaged practitioner in graphic design may well be operating from a distinct personal position with a number of central concerns in their work that extend beyond individual projects. Engaged practice may be driven by social, political, moral or other ideological positions about the function and consequences of design production. Debate about this area of working has informed the discourse surrounding the discipline of graphic design in recent years and could be seen as part of the discussion surrounding the notion of graphic design and authorship (pages 42-43).

offers the opportunity for critical reflection on the work in general. In projects where the designer has acted in an authorial way, its synthesis may also involve a reflection upon the less successful avenues taken in the work, as well as expected and unexpected results.

In projects where a particular theory or set of theoretical ideas have been explored and tested, the synthesis may require an analysis of how the initial work undertaken can be translated by the designer into a final set of visual outcomes. The questions posed by this kind of research may even result in a set of further questions as an outcome. In this instance, the synthesis of the research may be in the exploration of the most appropriate visual form in which to present the work. This may, for instance, result in work that establishes the context of the question(s) posed or may provide a commentary explaining how the

questions were arrived at. In applied projects, such as one commissioned by a client or a project rooted in a particular industrial context, the synthesis will entail the analysis of a number of detailed factors.

These factors would include the historical and contemporary background to the project – taking existing precedents, established conventions and the context of the work into account – its audience and its relationship to other existing work in the area under investigation, as well as an exploration of relevant media, including materials and production processes, and possible alternatives. This will be combined with any specific technological and budgetary considerations that have emerged during the research, and a reflection upon any testing and feedback that has taken place. This provides the basis for the final stages of the research that will converge

this information into a singular outcome. In some cases the methodology employed may be the outcome to the project in itself, rather than a developmental phase. This can take a number of forms including the documentation of individual but related tests, which chart the progress of the investigation. This is particularly relevant in areas such as materials testing, or in those projects like Sarah Backhouse's investigation into the effects of typography and layout in enhancing the sense of temporality and narrative in the design of fiction books (pages 150-155).

As with any valid research question, the outcome of a project is not immediately predictable: indeed, if it were, there would be no need to undertake the research. It is therefore important to develop a degree of flexibility within a working research methodology. Often during the final stages of a research project,

early ideas can be transformed to suggest a number of unexpected or alternative outcomes. It could be argued that this flexibility is inherent in graphic design practice, and that it is part of the intuitive approach of many designers.

The methods and approaches outlined in this book are an attempt to move beyond the already overstated case for intuition and the designer's 'creativity' and 'imagination'. Often when the discussion of creativity is introduced in design debate it masks a laziness on the part of its advocates – an unwillingness to engage in a more rigorous and exacting procedure for making, and a fear that, if revealed, it might alienate clients and audience alike.

Far from adding what has been described as 'intellectual glamour' to the practice of graphic design,

Topography
A detailed description of spatial configuration. The word could be employed to describe a process of mapping, documenting or recording, often with particular reference to what is occurring below the surface. Useful in graphic design research to describe an underlying approach to a project or a working method or process.

the adherence and commitment to a method of working, grounded in research and practical methods with clear aims, is a significant development in the growth of the discipline. In his essay *Thinking the Visual: Essayistic Fragments on Communicative Action* the Dutch designer and educator Jan van Toorn has described the graphic designer as a *'practical intellectual... someone who is actively engaged in critical reflection about the designer's process of making'*. It is this activity of 'critical reflection' that van Toorn suggests is crucial to the designer's research. In fact van Toorn relates the notion of the 'practical intellectual' to an informed and engaged practice in general. This approach to graphic design is rooted both in the practice and a reflection upon that practice, and is closer to the more accepted notion of graphic design (at least from within the discipline) as a problem solving activity.

The American writer, designer and educator Andrew Blauvelt, in his essay *Remaking Theory, Rethinking Practice*, argues for a closer integration of theory and practice and a critical reflection *in* work, rather than *about* work: *'critical thinking and making skills are crucial for success... Questions that cannot be answered with a simple yes or no are, in fact, research questions. And if the practice of graphic design is more than an unending series of solutions to never-ending problems, then we might begin to understand graphic design as a researchable activity, subject to both the limits of theory and the limitations of practice.'*

Critical Thinking

In concise terms, critical thinking is an attitude towards visual communication that is grounded in theory and its relationship to making. It is more than a philosophical position: informed or engaged practice is less about the ways in which theory can inform practice – it is graphic design engaged in the theory of practice, or *praxis*.

As the American designer and writer Andrew Blauvelt has observed, *'graphic design does not begin nor end in the objects it makes'*.

Critical thinking could be described as an important aspect of reflective practice – the consideration of the effects and consequences of graphic design activities. In general, reflective practice in graphic design could be described as locating the practice of graphic design as the subject of graphic design. Reflection in a designer's approach could encompass critical thinking about the meaning, function and value of what is produced and its relationship to the intentions of the individual designer and their audience.

Subject matters

Subject matter for the designer is

There is a growing recognition that a wide-ranging education is needed for a synthetic

an indeterminate problem, made

and integrative field such as design to progress. Synthetic in that design does not

only partly determinate by the

have a subject matter of its own: it exists in practice only in relation to the requirements

interests and needs of clients,

of given projects. Design is integrative in that, by its lack of specific subject matter,

managers and the designer.

it has the potential to connect many disciplines.

Richard Buchanan

Gunnar Swanson

Case Study 09: Language and Text

Graphic designer Paul McNeil's structured series of investigations into typography, writing and language concentrate specifically on procedures of visual experimentation. Using the <Context-Definition> methodology introduced on pages 56 and 57, McNeil made a number of key decisions about his chosen approach to the investigation early on the process of defining the parameters of the project. His interest in writing systems and background in font design provided much of the original impetus and focus for the project. McNeil established a systematic way of working which allowed him to explore a very wide variety of deliberately small-scale experiments, all of which attempt to address individual aspects of the overall objective of the work: to define a set of possible systemic parameters for writing (the field of study). By electing to work to a standard format – A5

portrait booklets – for each aspect of the project, he was able to make a comparative analysis of the work as it progressed. Whilst each sub-project can be viewed on its own, the intention was to use each experimental stage to inform the next stage, and to build progressively towards a collection of volumes of experiments and investigations that, in themselves, would make up the final outcome to the project. McNeil describes these individual elements as *'topographic fragments of a work in progress'*.

Each of these sub-projects were produced in a standardised format comprising a proposition, a methodology and the subsequent visual tests. By purposefully limiting the scope of each project, McNeil was able to interrogate a particular aspect of written language in detail, thus allowing him to be continuously aware of his decision making processes

and to build upon these as a significant aspect of his approach, while also allowing for digression and failure. Individual experiments explored different aspects of typographic form and language. These ranged from simple investigations such as the effect of mirror symmetry on letters of the Roman alphabet, to the creation of visual systems which allowed McNeil to document aspects of language such as the frequency of letters and sounds in speech, to studies of legibility and readability in relation to the amount of information needed to communicate, and to propositions based on the notion of type design as a purely generative system.

This process of critical making builds upon Jan van Toorn's concept of the graphic designer as the 'Practical Intellectual'. This, in van Toorn's definition, is an individual who is *engaged in critical reflection*

about the designer's process of making'. McNeil has made this concept a central feature of his work, and has advanced the idea by focusing his project on how this is documented and communicated. McNeil describes the objective of the project in this way: *'dedicated not solely towards its subject – writing and language systems – but to transferable systemic methods, to algorithmic systems in general, and to a conscious personal rediscovery of the pleasure of visual research'*. In each case, McNeil developed a methodology which allowed him to document his exploration of a particular theme, such as tonality, but also to find an appropriate manner to convey the ideas in such a way that they provided a visual commentary on the work as it progressed.

Generative Systems

Generative systems are employed by the designer in the process of form making. The phrase – drawn from tangential design subjects such as architecture and engineering – is intended to encompass design activities that have a direct influence on the form of what is produced. The study or use of generative systems as part of a working design research methodology involves an understanding of the explicit relationship between the systematic (the process, considerations and decision making processes) and the final visual form or product (its properties, composition and performance). In the case of Paul McNeil's work, this involved the development of a series of tests that eventually led to the creation of a visual system that would generate forms – in this case letterforms based on a fixed number of components and parameters.

Intentionality

Intentionality is a useful term in graphic design in relation to the purpose or function of the design by its creator or intended audience. It is often discussed in philosophical terms, especially in relation to language – some philosophers argue that intentionality is characteristic of a concept or an intention.

In philosophy, intentionality is related to mental states such as remembering, believing, knowing or experiencing, as well as to the concept of free will.

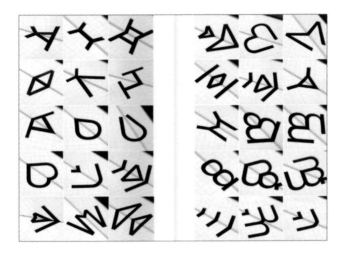

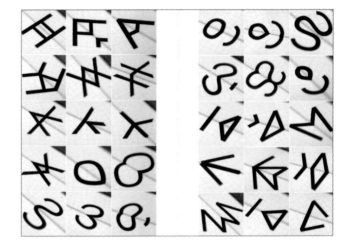

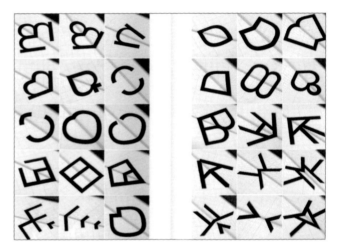

Paul McNeil's intention in the experiments shown on this spread was to examine aspects of symmetry and asymmetry in the Roman alphabet in order to uncover hidden forms and possible suggestions of lost images within individual glyphs. Having classified standard letterforms by symmetrical type (set against vertical axis, horizontal axis, angled axis, double axis, rotational axis or asymmetrical axis), basic symmetries were recorded photographically, using mirrors placed over gridded outputs of the characters.

The resulting images, of which only a small sample is shown here, were then converted back on to a typographic format (opposite page).

McNeil continued his experiments by attempting to subvert the stucture of alphabetic wordforms in order to automatically display aspects of frequency within the English language. In the typeface design shown (above left) characters were scaled incrementally from the least frequent and smallest (z) to the most frequent and largest (e) and located within a fixed grid with no allowance for spacing – disabling the convention that allows sequentiality in written language.

When any word is keyed in this typeface, its frequency pattern spontaneously becomes visible, each word forming a non-sequential chart of its own character frequency and thus realising patterns in the language. This image (top right) develops this idea further by mapping the frequency register (in white) over infrequency (in black).

Earlier versions of the typeface using capitals only (bottom right), designed to demonstrate high frequency (left) and median frequency (right).

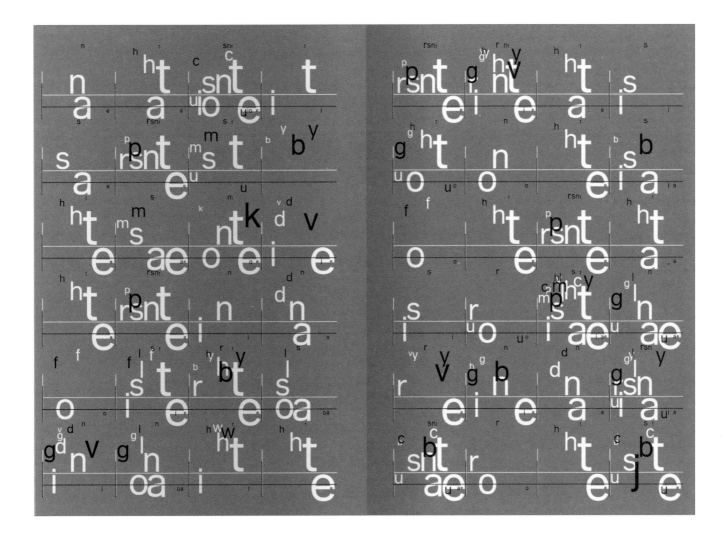

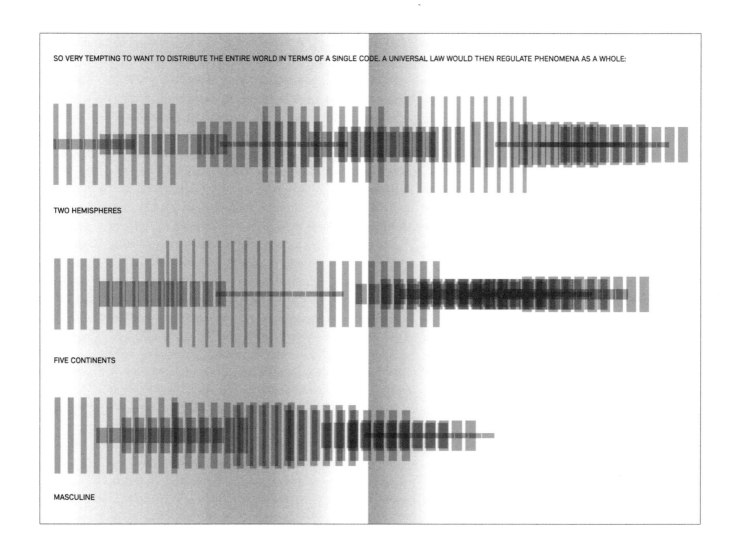

SO VERY TEMPTING TO WANT TO DISTRIBUTE THE ENTIRE WORLD IN TERMS OF A SINGLE CODE, A UNIVERSAL LAW WOULD THEN REGULATE PHENOMENA AS A WHOLE:

TWO HEMISPHERES

FIVE CONTINENTS

MASCULINE

Following the research conducted into individual letterforms and their frequency of use in the English language, McNeil extended his range of experiments to look at the internal typographic structure of letterforms and their use within an alphabetic system of differences.

Shown here is a series of visual propositions further extending notions of character frequency occurrence. The objective of these developments was to divert conventions of written form to serve as direct visual metaphors for both frequency and tonality, by replacing glyphs with blocks in synthesised tones of grey, in the form of line screens. After producing a number of initial designs (bottom right) McNeil developed the examples above. Here character widths, heights and internal structures are intended to represent duration, pitch and tone respectively.

These forms can subsequently be reconverted to sounds, whose 'legibility' can only be imagined.

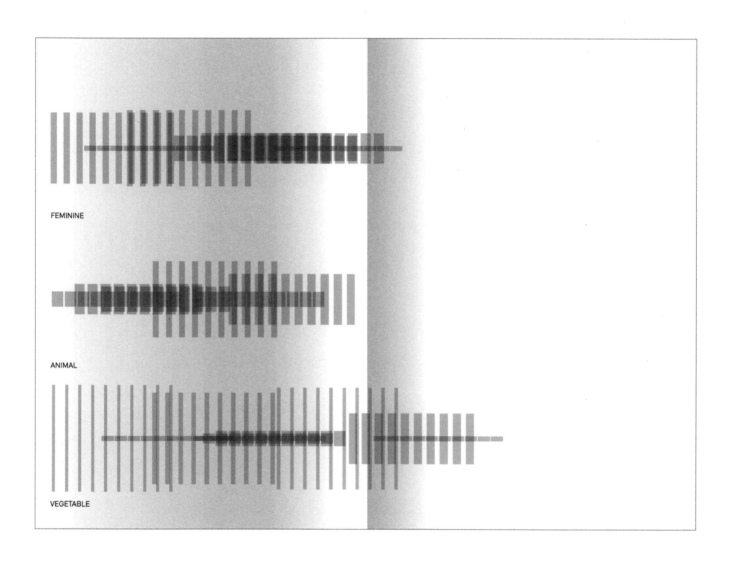

FEMININE

ANIMAL

VEGETABLE

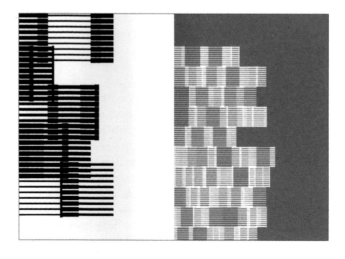

To playfully examine the significance of internal glyph skeletons in conveying meaning, McNeil constructed a typeface that is capable of generating words and sentences, but which disallows the appearance of individual letterforms (above). Internal character shapes are forced to merge, leaving only the exoskeletons of wordforms, though traditional typographic patterns are retained so that, at first glance, texts look 'correct'.

This unicase alphabet (opposite top) attempts to reduce the inherent ambiguity and redundancy of the Roman alphabet by amalgamating variant upper case and lower case glyphs from a total of 42 to 26 – the higher number being accountable to the graphic differences between characters such as E/e, A/a, R/r. The intention was to increase legibility by maximising key differences between glyphs.

To understand the hierarchy of stroke types in the alphabet McNeil classified it into separate components and then reconstructed every combination of stroke type (opposite middle). Characters were categorised by the lines used: curvilinear, elliptical and circular strokes, vertical strokes, horizontal strokes and diagonal strokes.

This experiment (opposite bottom) is one of a series of attempts to investigate the hierarchy of structural zones in Roman alphabetic words. The alphabet can be divided horizontally across four or five key zones both in terms of typographic construction and in the process of reading: ascender zone, upper x-height zone, baseline zone and descender zone. In this series of designs McNeil sliced individual glyphs into these key zones and reconstructed every combination of all zones.

Paul Fitchett
MFA Typographic Studies
ECD 2007
01932 567890

Uppercase lowercase

ABCDEFGHIJ
KLMNOPQR
STUVWXYZ
abcdefghij
klmnopqr
stuvwxyz
0123456789

slice
one
two
three
four
five

living in the midst of signs
had very slowly brought us to
see as so many signs the
innumerable things that had
at first been there without
indicating anything but their
own presence, it had
transformed them into signs
of themselves, and had
added them to the series of
signs deliberately made by
whoever wanted to make a
sign. the series of signs
multiplied itself into the
series of signs of signs, of
signs repeated an
innumerable number of
times, always the same and
always in some way different
for to the sign made on
purpose was added the sign
fallen there by chance

GLOSSARY OF TERMS

FURTHER RESOURCES

INDEX

Glossary of Terms

Affordance

The concept of affordance was first introduced by the perception theorist J.J. Gibson. *Affordances* are the range of possibilities that an object or environment offers (or appears to offer) in order to perform an action upon it. The classical example is that of the door, whereby the presence of a flat metal plate would indicate that the user needs to push, whereas a grab handle would indicate the need to pull the door open.

Donald A. Norman, in his book *The Design of Everyday Things,* explains how the reinforced glass panels erected by British Rail and used as the shelters for railway passengers were shattered by vandals as soon as they were replaced. The situation changed when they decided to substitute the glass panels for plywood boarding. Although the force needed to break the plywood was equivalent to that of the glass, the shattering stopped. Instead of smashing them, the vandals carved the wood or wrote on its surface. Glass allows us to see through it and can be shattered into a thousand pieces. In this 'psychology of materials' the affordances of wood make it rather more appealing to write on or carve than to smash.

Audience

A group of spectators or listeners at a concert or a play, or the people reached by a book, film, radio or television programme for instance. The audience for a graphic design product is usually clearly defined by the client or, following a period of primary research, by the designer in consultation with the client. The term 'audiencing' refers to the ways in which readers interpret and understand texts. Surveys of audience reading are often based on methods adopted from qualitative social science, such as interviews and ethnographic studies, together with quantitative methods based on statistical analysis.

However, one further model for graphic designers to consider is the reflective critical interpretation of images, which can often include a personal deconstruction of existing work or a critical reflection on work being undertaken by the designer himself. Through this analysis of design methods, the designer can become more expert in the range of forms and approaches suitable for a particular context or audience.

Authorship

The involvement of the designer in the mediation of the message to an audience. It can be argued that through the creation of visual messages, the designer has an equal role to play in the ways in which a piece of visual communication is read as the originator of the message itself. The designer, as a form-giver or channel through which the message is passed, can play a key role in actually shaping the content of the message. Some design theorists have borrowed the notion of the *auteur* from film theory in an attempt to build on this notion, while others have been provoked into a heated response which foregrounds the neutral role of the graphic designer within a commercial arena.

Avant-garde

From the French term meaning literally the vanguard or front-runner. In the context of art and design, the term avant-garde is usually employed to describe the pioneers or innovators of a particular period or movement, often in opposition to the mainstream or status quo. Both avant-garde and vanguard were created by combining the old French words 'avant', meaning 'fore', and 'garde', meaning 'guard' and relate to its original usage by the military.

In graphic design the term avant-garde is rarely used in the discussion of contemporary design activity – more often than not the phrase is applied when discussing the history of the subject. This is not to suggest that there is no current avant-garde in graphic design, simply that the phrase has passed out of common usage.

Communication Theory

The body of work which relates to the study of communication and the ways in which meaning is transferred between individuals and groups through language or media.

Connotation

The range of secondary meanings within a form of communication (such as a text; written, verbal or visual). The meaning of the image and how we 'read' it is not fixed by its creator or author but is equally determined by the reader. As such, there are often a range of personal interpretations of the meaning inherent within a message across the audience spectrum. Certain subcultural groups, for instance, may use visual signs that are adopted from the parent culture but are used to signify alternative meanings to their primary denotative signification.

<Context-Definition>

Initial work in this model usually involves a thorough analysis of a broad range of secondary research, mapping the territory to be investigated and determining the range of work which has already been done within the target context. Once a solid understanding of the context has been reached, the focus for the project can be determined, and a working methodology defined. Primary research is usually beneficial at this stage, in the form of direct surveys of target audiences and visual experimentation to test appropriate visual languages. The results of these preliminary visual and contextual experiments can then help to define the specific project intention, together with an appropriate methodology which allows the testing of a range of potential outcomes.

<Context-Experiment>

Initial work in this model usually involves a looser mapping of the territory to be investigated, an analysis of the range of work which has already been done within the same context, and a specified intention for the work within this context. The focus for the project needs to be determined earlier than in the <Context-Definition> model, particularly the definition of what the designer, and the client where appropriate, wishes to achieve. Distinct visual experiments to test appropriate visual languages and strategies are then conducted in order to determine a

range of potential solutions. It is important that an overarching strategy is employed by which to critically evaluate and reflect upon the relationship between each individual experiment.

Critical Reflection

The process by which the designer reviews a project outcome or evaluates the success of an experiment, by testing its effectiveness against a predetermined set of criteria. These criteria may be either self-imposed or may be a part of the brief itself.

Critical Thinking

In concise terms, critical thinking is an attitude towards visual communication that is grounded in theory and its relationship to making. It is more than a philosophical position: informed or engaged practice is less about the ways in which theory can inform practice – it is graphic design engaged in the theory of practice, or *praxis*. As the American designer and writer Andrew Blauvelt has observed, *'graphic design does not begin nor end in the objects it makes'*.

Critical thinking could be described as an important aspect of reflective practice – the consideration of the effects and consequences of graphic design activities. In general, reflective practice in graphic design could be described as locating the practice of graphic design as the subject of graphic design. Reflection in a designer's approach could encompass critical thinking about the meaning, function and value of what is produced and its relationship to the intentions of the individual designer and their audience.

Deconstruction

The term deconstruction denotes a particular kind of practice in reading, and a mode of analytical critical enquiry. It is a theory of reading which aims to expose and undermine the logic of opposition within texts (both written and visual). This critical analysis sets out to question the priority of things which are set up as original, natural, or self-evident. Deconstructive readings are often part of a broader form of interpretation based on a firm critical position (for instance feminist, new historicist or Marxist critique). As such, they are often used to destabilise the range of inherent hierarchical oppositions in the text.

Denotation

The primary, literal meaning of a piece of communication, usually within a particular target audience or group of readers. This aspect of reading (decoding) and writing or making (encoding) meaning within a message is fundamental to all forms of communication. Graphic designers need to be aware of the uses of particular visual signs and symbols, and their common meanings, within a target group. Information design, and the other areas of graphic design which attempt to reach a broad audience, rely heavily on the denotation of specific meanings within visual forms in order to make the intended message clear.

Discourse

A body of verbal or written communication, especially between two or more participants. The act of discussion between parties, often in a formal manner.

Epistemology

The theory of the underlying methods or grounds of knowledge and the critical study of the validity, methods and scope of an established body of knowledge. In relation to graphic design, this indicates the body of widely accepted knowledge that defines the discipline, including those theories surrounding legibility, written language and typography, as well as those drawn from outside of the profession.

Generative Systems

Generative systems are employed by the designer in the process of form making. The phrase – drawn from tangential design subjects such as architecture and engineering – is intended to encompass design activities that have a direct influence on the form of what is produced. The study or use of generative systems as part of a working design research methodology involves an understanding of the explicit relationship between the systematic (the process, considerations and decision making processes) and the final visual form or product (its properties, composition and performance).

Gestalt

The organisation of a whole that is more than the sum of its parts. The implication of meaning communicated through the use of a part of an image or object, rather than the whole.

Informed Engagement

An informed or engaged practitioner in graphic design may well be operating from a distinct personal position with a number of central concerns in their work that extend beyond individual projects. Engaged practice may be driven by social, political, moral or other ideological positions about the function and consequences of design production. Debate about this area of working has informed the discourse surrounding the discipline of graphic design in recent years and could be seen as part of the discussion surrounding the notion of graphic design and authorship.

Intentionality

Intentionality is a useful term in graphic design in relation to the purpose or function of the design by its creator or intended audience. It is often discussed in philosophical terms, especially in relation to language – some philosophers argue that intentionality is characteristic of a concept or an intention. In philosophy, intentionality is related to mental states such as remembering, believing, knowing or experiencing, as well as to the concept of free will.

Linguistics

The scientific study of language and its underlying structure.

Materiality

This relates to the physical properties of an object. In graphic design this might mean the physical nature of a book for example – how it

is printed, its binding, the materials it is constructed from and its status as an object beyond its content and functionality as a form of communication. An approach to design which focussed on materiality would encompass the relationship of the physical properties of the book to its intended audience and the relevance of how it is presented as a whole. This aspect of design is sometimes referred to as the plastic or 'plastique' of an object, in relation to the combination of a number of elements into a whole.

With reference to the visual arts in general, the term is derived from the phrase 'plastic arts' in particular referring to three-dimensional art such as sculpture. In the context of graphic design, materiality or plasticity can also refer to an activity where there is no physical object present – including screen based, interactive and virtual environments such as the internet or cyberspace.

Method
A way of proceeding or doing something, especially in a systematic or regular manner.

Methodology
The science of method, or a body of methods, employed in a particular activity such as the research aspects of a project. A logical, predefined, and systematic strategy by which to undertake a graphic design project, to include methods of evaluation of experimental outcomes, a schedule for each stage of the project and a stated intention or purpose in relation to anticipated outcomes. It could also be employed to describe an approach to graphic design in general: a particular manner of working or a procedure used in the production of graphic design. Sometimes used in reference to organisation or a technique of organising and analysing, or a scheme of classification.

Modernism
Many of the early 20th century art and design movements connected to modernism, such as De Stijl, constructivism and the Bauhaus, endeavoured to celebrate functionalism and rationality under the maxim that 'form follows function'. The modernist approach to layout and design in general focused upon the use of white space and sans serif typography that utilised asymmetry. This was driven by an adherence to the grid, based on geometry and the proportion of the page, as a controlling device.

Postmodernism
A movement that grew out of a rejection of the ideas of modernism. Many of the original values of modernism were, by the late 1960s, regarded by designers as dogmatic and only offering a fixed view or superficial style. Postmodernism celebrated a return to earlier ideas of the value of decoration. Rejecting order or discipline in favour of expression and intuition, many of the key progenitors within the field emanated originally from schools such as Basel in Switzerland and later Cranbrook in the US, and were tutored by central figures such as Wolfgang Weingart and Katherine and Michael McCoy. The postmodern lexicon of historical reference, decoration, wit and the

ironic employment of vernacular or non-designed elements, such as hand drawn typography, constituted a departure from the rationality of earlier approaches.

Post-structuralism
A body of theory relating to the distinctions between speech and writing. The French philosopher Jacques Derrida in his seminal work *On Grammatology* challenged the idea that speech is more important than writing. Derrida stated that all systems or structures have a centre – a point of origin – and that all systems are constructed from binary pairs that are in relation or opposition to each other.

Practical Problems: Applied Research
A practical problem originates in the real world and is related to pragmatic issues and conditions such as cost, production and technology. It may also be influenced by its context, such as the need to explore legibility and typographic form in relation to public signage for the poorly sighted. Within an applied area of research and investigation, the solution itself may lie in constructing or posing a specific research problem. The outcomes of applied research are tangible and offer real world or commercial solutions to already existing needs.

Primary Research
The raw materials which a designer works directly with in relation to research. Primary research approaches might include marketing strategies such as audience surveys or interviews, or the direct testing of potential visual solutions within a 'real world' context.

Qualitative analysis
Qualitative analysis is based on subjective responses to visual forms and the reading of graphic material by a viewer. Often this is done by the designer him- or herself, in the form of critical self-reflection. The reading of images and visual signs through semiotic analysis is, however, a qualitative act in itself: although the responses can be evaluated statistically as a form of quantitative analysis, the initial data gathered is based on human reaction to the visual forms and experiments presented.

Quantitative analysis
Quantitative analysis is based on mathematical principles, in particular statistical methods of surveying and interrogating data. By generating a batch production of visual forms to test, the designer can place these objects in specific locations in order to 'count' positive and negative responses from a target audience. This could mean conducting a survey within the target audience group, perhaps with multiple choice questions devised to score against a set of criteria. The data gathered can then be analysed statistically to find the most successful visual form.

Research
A critical investigation or a search or inquiry to discover new facts and information or to collect and collate old data. This would encompass

Glossary of Terms

the study of a subject, employing the analysis of quantitative and/or qualitative data. Research employs methods and schemes of testing to interpret events, facts or information, and is a process of observation, discovery and recording. In the context of graphic design, research provides the foundations of the design process of problem solving and visual communication. The research component of a graphic design brief can take a singular form in some projects such as the collation of audience feedback to a proposal or it can operate in a number of forms simultaneously, each body of research findings working together and in tandem to inform the overall approach to a project.

Research Problems: Pure Research

A research problem is typically developed in response to a subject or theme that the designer does not know or fully understand. A research problem may arise from, or be motivated by, a practical problem to be resolved – *a field of study*. This then helps to define the *Focus* of the research and provides a specific question to be explored. The research, investigation and development – the body of knowledge and understanding gained through research – is then applied to a practical situation or problem. Sometimes this is referred to as pure research and its outcomes are frequently conceptual, for instance in the development of an appropriate visual vocabulary for a specific theoretical context. Although this form of research may not lead to 'real world' practical solutions, this does not obviate the need for a thorough analysis of the context of the work in relation to potential audience and the stated project intentions. The outcomes of pure research are propositional and offer potential visual solutions to as yet undefined needs.

Rhetoric

The study of the technique of the effective use of language. Written or spoken discourse used to persuade, influence or affect an audience.

Secondary Research

Established or existing studies already undertaken in the field and used to support the designer's own research. This might include published surveys and/or interviews with potential audience groups, together with the analysis of a range of successful visual communication strategies within a similar context.

Semantics

The branch of linguistics that deals with the study of meaning. The study of the relationships between signs and symbols and the meaning that they represent.

Semiotics

The study of signs and symbols, especially the relationship between written or spoken signs and their referents in the physical world or the world of ideas. A core strategic method by which graphic marks, texts and images can be deconstructed and interpreted to determine their underlying meanings.

Tertiary Research

Research based on secondary sources and the synthesis of the studies of others to simply restate what others have undertaken. A summary of the existing body of knowledge and accepted methodologies relating to the range of intentions, audience and context of the project.

Text

The use of the word text refers to more than the printed word on a page in a book. It also encompasses a range of other activities and items related to cultural production. This would include for example a film, a wrestling match on television or a building – anything that carries meaning and that could be 'read' by an audience. In the late 1960s and early 1970s the French philosopher Roland Barthes began to challenge the existing idea that the author of a book could be considered as the central and controlling influence on the meaning of a text.

In his essays *The Death of the Author* and *From Work to Text*, Barthes argues that whilst it is possible to trace the influence of the author in a text, the text itself remains 'open', encouraging the idea that the meaning is brought to an object – particularly a cultural object – by its intended audience. In this way, the meaning does not intrinsically reside in the object itself and cannot be reduced to an authorial intention.

Topography

A detailed description of spatial configuration. The word could be employed to describe a process of mapping, documenting or recording, often with particular reference to what is occurring below the surface. Useful in graphic design research to describe an underlying approach to a project or a working method or process.

Typology

The study and interpretation of types – for instance, a person, thing or event that serves as an illustration or is symbolic or characteristic of something. The phrase also relates to the organisation of types and their classification for the purposes of analysis.

Books and Key Texts

Barnett, R.
Higher Education: A Critical Business
London: Open University Press, 1997

Barthes, R.
Mythologies
St. Albans: Paladin, 1973

Barthes, R.
Image, Music, Text
London: Fontana, 1977

Baxandall, M.
Patterns of Intention: On the Historical Explanation of Pictures
Yale University Press, 1985

Berger, J.
Ways of Seeing
London: Penguin, 1969

Crow, D.
Visible Signs – An Introduction to Semiotics
Lausanne: AVA Publishing SA, 2003

Edwards, E. & Hart, J. (Eds.)
Photographs Objects Histories: On the Materiality of Images
London: Routledge, 2004

Emmison, M. & Smith, P.
Researching the Visual: Introducing Qualitative Methods
London: Sage, 2000

Flusser, V.
The Shape of Things: A Philosophy of Design
London: Reaktion, 1999

Frascara, J.
User-Centred Graphic Design
London: Taylor & Francis, 1996

Harvey, C.
Databases in Historical Research: Theory, Methods and Applications
London: Macmillan, 1996

Hawkes, T.
Structuralism and Semiotics
London: Methuen, 1997

Kress, G. & van Leeuwen, T.
Reading Images
London: Routledge, 1996

Laurel, B. (Ed)
Design Research: Methods and Perceptions
Cambridge, Mass: MIT Press, 2003

Lupton, E. & Abbott Miller, J.
Design, Writing, Research – Writing on Graphic Design
London: Phaidon, 1996

Margolin, V. & Buchanon, R. (eds.)
The Idea of Design – A Design Issues Reader
Cambridge, Mass: MIT Press, 1995

Norman, Donald A.
The Design of Everyday Things
London: MIT Press, 1998

Northledge, A.
The Good Study Guide
London: The Open University, 1993

O'Sullivan, T. (et al.)
Key Concepts in Communication
London: Methuen, 1983

Poynor, R.
Design Without Boundaries
London: Booth-Clibborn, 1998

Poynor, R.
Obey the Giant
London: Berkhauser, 2001

Poynor, R.
No More Rules: Graphic Design and Post-Modernism
London: Laurence King, 2003

Rose, G.
Visual Methodologies: An Introduction to the Interpretation of Visual Material
London: Sage, 2001

Schön, D.
The Reflective Practitioner
New York: Basic Books, 1993

Tufte, Edward R.
The Visual Display of Quantitative Information
Cheshire, Conn: Graphics Press, 1983

Tufte, Edward R.
Envisioning Information
Cheshire, Conn: Graphics Press, 1990

Tufte, Edward R.
Visual and Statistical Thinking: Displays of Evidence for Making Decisions
Cheshire, Conn: Graphics Press, 1997

Tufte, Edward R.
Visual Explanations: Images and Quantities, Evidence and Narrative
Cheshire, Conn: Graphics Press, 1997

Walker, John A.
Design History and the History of Design
London: Pluto, 1989

Walker, John A. & Chaplin, S.
Visual Culture: An Introduction
Manchester University, 1997

Wolff, J.
The Social Production of Art
London: Macmillan, 1981

Journals

Eye
Emigré
Visible Language
dot dot dot
Baseline
Zed
Design Issues

Web Sites

Design Observer
www.designobserver.com (04.04)

American Institute of Graphic Arts
www.aiga.org (04.04)

Design Institute: The Knowledge Circuit
http://design.umn.edu (04.04)

Design, Writing, Research
www.designwritingresearch.org (04.04)

Speak Up
www.underconsideration.com (04.04)

Eye Magazine
www.eyemagazine.com (04.04)

Typotheque
www.typotheque.com (04.04)

Adbusters
www.adbusters.org (04.04)

NextDesign Leadership Institute
http://nextd.org (04.04)

Contributing Designers

Matt Cooke
Telephone: +1 [415] 250 5837
Email: matt@mattcooke.org
Web: www.mattcooke.org

Alison Barnes
Telephone: +44 [0]79 4454 4365
Email: alison.barnes@ntu.ac.uk

Wayne Daly
Telephone: +44 [0]79 5222 1836
Email: wayne@waynedaly.com

Sharon Spencer
Email: sharonspencer@madasafish.com

Sarah Backhouse
Email: sarah-b@ntlworld.com

Fintan McCarthy
Telephone: +44 [0]78 1531 7261
Email: carthf@yahoo.com
Web: www.printscreenf13.com

Paola Faoro
Telephone: +44 [0]79 5637 0790
Email: mail@paolafaoro.com.br
Web: www.paolafaoro.com.br

Anna Plucinska
Telephone: +44 [0]77 7584 8919
Email: aplucinska@hotmail.com

Paul McNeil
Telephone: +44 [0]1932 565631
Email: paul@type.demon.co.uk

Photography

Sarah Dryden
Email: drydensarah@hotmail.com

Index